SHIPWRECKS
OF THE
DELAWARE
COAST

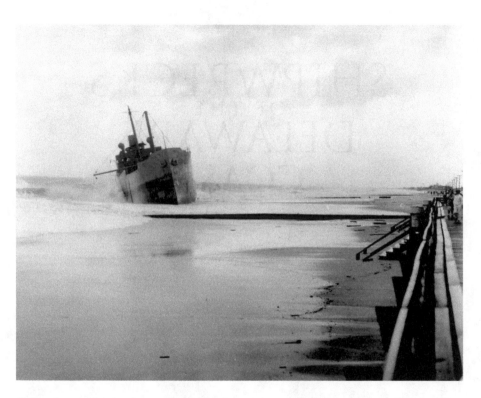

Although weighing in at more than seven thousand tons, the freighter *Thomas Tracy* was no match for a hurricane. In 1944, the ship ran aground on Rehoboth Beach. *Courtesy of the Delaware Public Archives.*

PAM GEORGE

SHIPWRECKS
OF THE
DELAWARE
COAST

TALES OF PIRATES, SQUALLS & TREASURE

THE
History
PRESS

Published by The History Press
Charleston, SC 29403
www.historypress.net

First published 2010
Second printing 2011
Third printing 2012
Fourth printing 2012

ISBN 978.1.5402.2384.5

Library of Congress CIP data applied for.

CONTENTS

Acknowledgements

In a shed on the grounds of Cape Henlopen State Park in Lewes, Delaware, water streams off the verdigris copper sheath that runs along a soaked, jagged piece of wood. This is part of the hull of *De Braak*, a Royal Navy brig-sloop that sank off Cape Henlopen on May 25, 1798. Frequent watering keeps the relic from drying out and decaying, yet the stopgap effort will not keep the hull preserved for long. It requires more sophisticated technology.

I first stood before the ship's battered, broken hull in 2004 when I wrote a story on *De Braak* for *Delaware Beach Life* magazine. The sight in the hushed shed was surprisingly moving, as though I was looking upon a historical person's remains rather than the slightly musty remnant of a sailing vessel.

Rumored to be carrying gold and silver, the British warship was the focus of a frenzied treasure hunt that lasted for nearly two centuries. Pinpointing its location proved so challenging that some said the ship was guarded by a witch or spirit. It was finally found in 1984, and in the quest to find the gold, salvagers hauled the hull to the surface. There would be plenty of artifacts to ponder: cannons, cooperage, guns and eighteenth-century clothing—but no treasure. There is, however, plenty of history clinging to the ship's remains. Although not on public display, the hull is a tangible testament to the dangers faced by those who navigated the Delaware coast, which includes the Atlantic Ocean, the Delaware Bay and the Delaware River.

The sight of *De Braak* stayed with me, and my fascination for shipwrecks only increased. There are a lot of facts and figures surrounding some of these wrecks, from their tonnage to their lengths to the cargo they contained. Yet the human stories remain the most compelling, whether it is the courage of

the crew, the agony of the passengers or the heroism of those who attempted to save them. Whether from a historical or archaeological viewpoint, these vessels are indeed treasure-troves.

In putting this book together, I'd like to thank my husband, Steve, who was patient with me when I was "submerged" in writing it; Terry Plowman, publisher of *Delaware Beach Life*, who first asked me to write about the subject, as well as his staff, Ashley Dawson and Tessa Shoup; the staff at the Delaware Public Archives; Claudia Jew and Megan Evans at The Mariners' Museum in Newport News, Virginia, who were always pleasant when I asked for just one more photo; Mike DiPaolo at the Lewes Historical Society; Chuck Fithian, curator of archaeology for Delaware's Division of Historical and Cultural Affairs; Dale Clifton, executive director of the DiscoverSea Shipwreck Museum in Fenwick Island, a terrific resource; although I have not met them, Gary Gentile and Donald G. Shomette, whose books are fountains of information on this subject; Mark Nardone at *Delaware Today*; and all of the other editors who have generously allowed me to write about the subjects, namely the beach, that I love.

INTRODUCTION

To witness Delaware's shared legacy with the sea, stand on Lewes Beach, the khaki-colored stretch of sand that fronts the Delaware Bay. In the distance, two classic-looking lighthouses rise from the breakwaters that once provided shelter for ships during the frequent storms that ravage the area. A freighter lumbers along the horizon, headed to Philadelphia, Pennsylvania, located less than ninety miles up the river, while a tug chugs toward the Port of Wilmington.

Time the visit right, and you will catch one of the black-and-white ferries as it makes the seventeen-mile voyage from Lewes to Cape May, New Jersey. Since July 1, 1964, the ferry service has linked Cape Henlopen, Delaware, to Cape May, two geographical landmarks known for centuries as "the Delaware capes."

What you will not see, however, is the graveyard that exists below the white-capped waves. Brigs, barks, schooners, tugs, tankers and destroyers are embedded in the mud and the sand. When the tide in the Delaware Bay turns, a cloud of sediment swirls up like a tornado, blanketing the wrecks in blackness. The capricious current has been known to tear the masks off divers' faces and the respirators from their mouths.

Some of the ships' names are well known to historians, divers and artifact-seekers: the *Faithful Steward*, the *Elizabeth Palmer*, the USS *Jacob Jones* and *De Braak*. Some are so well documented that historians know personal details about many of the passengers who lost their lives. Others, though, are shrouded in mystery.

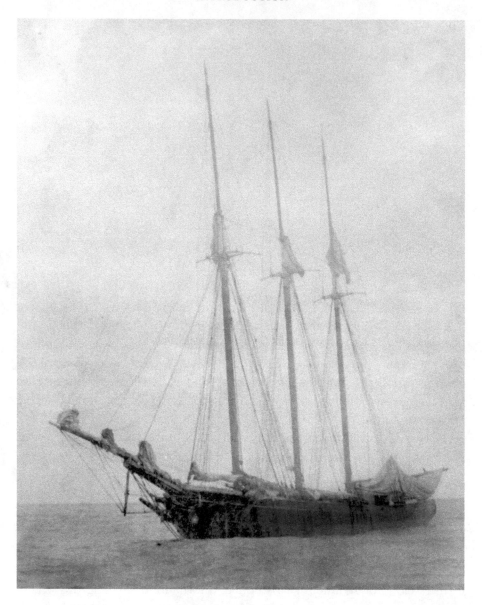

With few navigational tools and poor weather prognostication, schooners like the *John Proctor* were often at the mercy of storms and dangerous coasts. The schooner sunk off Cape Henlopen in 1901. *Courtesy of the Delaware Public Archives.*

The cause of other wrecks stems from inclement weather, human error and interference, war and what is widely recognized as a treacherous coastline liberally laced with shoals, rocks and shifting currents.

It is hard to estimate just how many wrecks are strewn along the Delmarva coast. In the country's early days, there were no accurate records, and sailing vessels simply disappeared. But the advent of steam power and better navigation did not prevent shipwrecks. Battleship and liner, tug and tanker, menhaden fishing boat and trawler—the ships that met their demises off the coast of Delaware are now united in a silty slumber.

But the mystique that swirls around them lives on, creating legends that will survive long after their battered remains have disintegrated into the sand.

HOPE, COURAGE AND CALAMITY IN THE NEW WORLD

DIAMOND IN THE ROUGH

Today, Delaware is often called the "Small Wonder" and the "Diamond State." For the latter nickname, some credit Thomas Jefferson, who once referred to the state as a jewel among the thirteen original colonies, due to its central and strategic location. In the seventeenth and eighteenth centuries, Delaware's location was seen as a major advantage to whichever country held the title to the land, and the Dutch, the Swedes and the English would all take turns claiming it.

The nickname "Small Wonder" could refer to the state's business-friendly climate, tax-free shopping or blend of rolling parks, historic and cultural attractions and beaches. In the colonial days, however, Delaware's attraction stemmed from its access to important maritime trade routes. The state's entire eastern border hugs the water. To the south, the towns cozy up to the Atlantic Ocean. The coast then dips inward around Cape Henlopen to welcome the Delaware Bay before stretching northward along the Delaware River, a vital portal to the towns of Wilmington, Delaware; Philadelphia and Chester, Pennsylvania; and Camden and Trenton, New Jersey.

Initially, Delaware's maritime potential was overlooked in one explorer's haste to find a northwest passage to China and the Indies. Henry Hudson, an English navigator employed by the Dutch East India Trading Company, discovered the Delaware River and the Delaware Bay on August 28, 1609. The waters near what is now Cape Henlopen were too shallow for his ship, the *Halve Maen* (*Half Moon*), so he meandered northward to discover the river

that would later carry his name. At that time, the Dutch called the Delaware River the "South River" and the Hudson River the "North River." The challenge of exploring the South River and the bay made an impression on Hudson, who later recommended that anyone who wanted to explore the shoreline around the bay needed a small vessel to carefully navigate its coast.

The next year, Captain Samuel Argall of Virginia sailed his pinnace to the entrance of the Delaware Bay and named the thumb of land there Cape La Warr in honor of Sir Thomas Charles West, Lord de la Warre, then governor of the colony of Virginia. Delaware would later become the name of the bay, the river and the land to the west of those waters.

In 1629, representatives of the Dutch West India Company, which was formed in 1621, purchased a tract of land in Delaware from the native people in exchange for cloth, axes, adzes, beads and various other goods. Samuel Godyn of Amsterdam had the rights to settle the new territory, and he put David Pietersz de Vries of Hoorn in charge. De Vries, in turn, instructed Captain Peter Heyes of *De Walvis* (*The Whale*) to establish a whaling colony in the area.

On December 12, 1630, *De Walvis* set sail from Holland with twenty-eight men. As the ship unfurled its sails, cutting through the frothy waves in the Atlantic, the would-be colonists were undoubtedly full of hope and a sense of adventure.

The ship arrived near present-day Cape Henlopen in 1631, and the men set up camp near Lewes Creek, which Heyes dubbed Hoornkill. (The name was later corrupted into Whorekill or Horekill.) They built a palisade, a dormitory and a cookhouse on a site christened Swanendael or, as an alternative spelling, Zwaanendael, which means "Valley of Swans," and their compound was named Fort Oplandt. In September, Heyes and *De Walvis* departed for Amsterdam, leaving the men well on their way toward being established. They had cattle and building supplies. All they lacked was luck. None would survive a year.

When De Vries landed *De Walvis* near Swanendael in 1632, he was met with a brutal sight. The bones of the men and the cattle were randomly strewn about the settlement in a violent chaos, and the buildings had been burnt to the ground.

One account, later given to De Vries by a Native American, credited the catastrophe to a tin coat of arms that the colonists had mounted on a pillar. An admiring chief took the emblem to make pipes. When the colonists complained, the tribe executed the alleged thief to appease them. Horrified,

the colonists rebuked the tribe, and their admonishment insulted the slain chief's friends. They took revenge, slaughtering every single colonist and destroying the property.

The ever practical De Vries made peace with the tribe and sailed on. "Thus the Delaware Bay was again abandoned to the Indians, and no people but they broke the solitude of its shores or trod the melancholy, blood-stained and desolate ground of the 'Valley of Swans' the site of Delaware's first settlement, for many years," writes J. Thomas Scharf in *History of Delaware: 1609–1888*.

Not for long. It was Sweden's turn next. A disillusioned William Usselinx withdrew from the Dutch West India Company to help King Gustavus Adolphus of Sweden start a trading company. Unfortunately, the king was preoccupied with the Thirty Years' War in Europe, and colonization efforts languished until 1637, when the New Sweden Company engaged Peter Minuit to direct a Swedish expedition.

In 1638, Minuit sailed the *Kalmar Nyckel* (*Key of Kalmar*) up the Delaware River to what is now Wilmington and set up a Swedish colony with twenty-four settlers of Swedish, Finnish, German and Dutch descent. (A black freedman joined them aboard the companion ship, *Fogel Grip*.) The *Kalmar Nyckel* would make a total of four crossings. The Dutch remained active. Peter Stuyvesant, governor of New Netherland, established Fort Casimir in 1651 on the site of present-day New Castle. The Swedes captured the fort in 1654, but Stuyvesant in 1655 conquered all of New Sweden.

Soon, areas from the Schuylkill River near Philadelphia down to the Delaware Bay were primarily composed of Dutch, Swedish and Finnish settlers. The English, however, were right across the river in New Jersey and creeping northward from Virginia and Maryland. As the colonies expanded, settlers needed more goods. It was easy to see the advantage of controlling the Delaware River.

In 1664, the English seized Dutch holdings on the Delaware. The Dutch recaptured the colony in 1673, but the tables turned in 1674 when the English took it back. The Duke of York (later James II) annexed the region to New York, and in 1682 the deed to the Delaware area was later transferred to William Penn, who arrived in New Castle in 1682. Under Penn's direction, Delaware was divided into three counties, stacked on top of one another due to the state's vertical shape. Sussex resides at the bottom, followed by Kent and then, near the border of Pennsylvania, New Castle County. Collectively, they were known as the "lower counties" in Penn's expansive territory. As

time went on, the lower counties felt disconnected from those in the north. Their allegiance was more with the English Crown than with Penn. They wanted to elect their own representatives, who were not necessarily aligned with Penn's interests.

In 1704, the three lower counties formed their own legislative assembly, under Penn's approval. But the laws still required his signature. It was not until June 15, 1776, that Delaware officially announced its independence—both from England and Pennsylvania. It was a bold move for a colony with just four thousand residents. The state commemorates the date each year with Separation Day.

The mélange of countries that contributed to Delaware's early history is easy to spot. In Lewes, the Zwaanendael Museum, modeled after the town hall in Hoorn, the Netherlands, stands out next to the town's many colonial and Victorian structures. Historic New Castle, which fronts the Delaware River, has many preserved areas crisscrossed with brick sidewalks. Here visitors can tour the Dutch House, built in the seventeenth century. The Christina River, named for Queen Christina of Sweden, curls around Fort Christina in Wilmington, where a replica of the *Kalmar Nyckel*, the state's goodwill ambassador, docks when it is home.

The historical remnants are today's tourist attractions, indelible imprints of those who helped shape the state. Yet some intrepid settlers and their predecessors would leave behind another legacy: the remains of their countries' ships under the waves off the dangerous Delaware coast.

A PATH FRAUGHT WITH PERIL

Without proper navigational tools and accurate weather forecasting, the sailing ships that first navigated these waters were playing a game of chance. Between perilous shoals, pirates, privateers, human error and unpredictable weather, it seemed the odds were stacked against them. But for those who made a living on the water, it was danger be damned.

To fuel the ruling European country's economy, its colonists by law had to purchase supplies from the mother country. Nails, millwheels, bricks, pins, shoe buckles—all the necessary items came from abroad. Consequently, ships laden with goods were continually heading to the colonies, and they would return heavy with the natural resources that would have helped make the colonists more economically independent. Even after the Revolutionary

War, the young country relied on Europe for such basic necessities as coinage, which was shipped over in barrels.

Due to the surge in trade, colonization and European wars, which spilled over into the New World with annoying regularity, shipwrecks became more common in the mid-Atlantic area. On August 19, 1695, Francis Nicholson, captain general and governor of Maryland, appointed Edward Green of Somerset County the first "wreckmaster." Green was instructed to seize all wrecks off the coast.

Detailed navigational charts were unavailable, and until certain sections developed a notorious reputation, encountering these hazardous areas was an unwelcome surprise to navigators. Both Delaware's coastline and its underwater geography present a formidable obstacle for ships without technology. Not only is the coast littered with rocky outcroppings that could tear a ship's hull to wooden shreds, but it is also laced with treacherous shoals.

The 1916 edition of *United States Coast Pilot: Atlantic Coast, Section C: Sandy Hook to Cape Henry including the Delaware and Chesapeake Bays* noted that the coast from Cape Henlopen to Cape Charles, Virginia, "is fringed with broken ground, on which lumps with depths up to 6 fathoms are found for distances of 8 to 11 miles from shore." Among the most infamous shoal is the Hen and Chickens Shoal, located off Cape Henlopen, so named because it is a large shoal surrounded by smaller shoals. In a 1916 survey, the shoal had a depth of just five feet. The Fenwick Island Shoal to the south that year had a depth of eleven feet. Other notable shoals include Overfalls and Brandywine. Like coastlines, shoals change over time; they expand and recede depending on weather, current and sea level, making it a challenge for those unfamiliar with the area.

As early as 1765 and likely before, ships stopped around Cape Henlopen to hire a pilot to take the ship up the river. Often as not in those days, the guide was a Native American. During the Revolution, pilots also served as lookouts. Pilot Henry Fisher in 1777 reportedly sped upriver in his boat *Marquis of Granby* to warn the War Board about the arrival of enemy ships heading north. By the end of 1789, the United States Congress recognized pilotage as an official trade governed by states.

In the 1800s, finding a pilot was like hailing a taxi today. Groups of pilots purchased a schooner and set up shop against competitors. When a vessel was sighted, the schooners would converge, vying for the job of taking the vessel up or down the river. There was a lot of grumbling and resentment

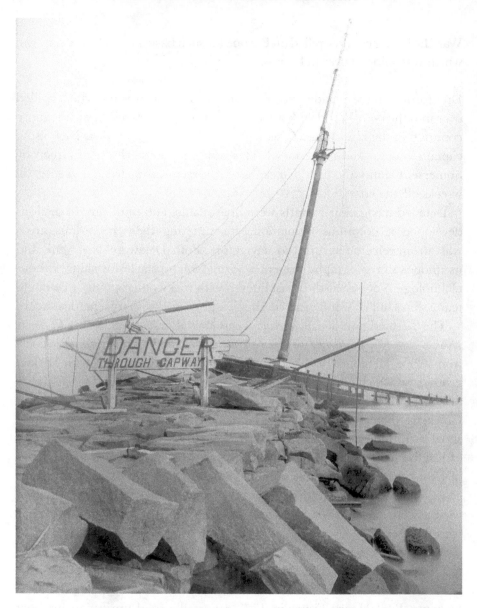

In 1899, the *M.E. Bayard* wrecked off the east end of Delaware Breakwater's icebreaker section. *Courtesy of the Lewes Historical Society.*

if one group repeatedly outdid another. Delaware pilots were under the Port Wardens of Philadelphia's control until 1881, when the Delaware Pilot System mandated that all pilots licensed by Delaware were subject to the Delaware Pilot Commission's regulations. In 1896, the Pilots' Association for the Bay and River Delaware was established with John Penrose Virden as its first president.

No matter how experienced the pilot, inclement weather made navigating Delaware's tricky waters more challenging. The Delaware coast is no stranger to nor'easters, ferocious storms named for northeasterly winds that blow in from the ocean, ahead of the storm. Nor'easters typically generate enormous waves that consume vast quantities of beach, leaving small cliffs above the shoreline. As they move up the coast, the rain can suddenly turn to snow. In 1888, a horrific March storm became known as the Great White Hurricane. The Ash Wednesday Storm of 1962, accompanied by a full moon, battered the coastline with rain, snow, sleet, wind and coastal flooding for five high tides.

The weather seemed to simply swallow some ships. The *Juno* is one example. A thirty-four-gun frigate in the service of the Spanish navy, the vessel in 1802 left Vera Cruz, Mexico, under the command of Captain Don Juan Ignacio Bustillo but took shelter in Puerto Rico due to storms. When the ship left Puerto Rico, it held more than four hundred soldiers and civilians. The *Juno* also contained silver and gold. In late October, the ship encountered a storm with gale-force winds, which split the sails. Ocean water poured onto the deck, flooding the hold. The *Juno*'s crew was no doubt ecstatic to see the *Favourite*, a merchant schooner. The two ships sailed alongside for two days in an attempt to get close enough for the *Favourite* to take the *Juno*'s passengers and crew on board. But the storm kept forcing them apart. Separated by a heavy fog, the *Juno* finally went under. Legend has it that those aboard the *Favourite* could hear the screams of the men, women and children. To this date, no one knows the location of the ship's remains, which could be anywhere from the Cape Henlopen area down to forty miles east of Assateague Island.

With winter came the threat of ice, which wreaked havoc on wooden ships and commerce. Cold weather in 1711 turned the Delaware River near Philadelphia into an ice-skating rink. A ship heading to Lisbon lost its foremast near the Delaware capes and was shredded by ice on the Brandywine Shoal, located about twelve miles above the entrance to the Delaware Bay.

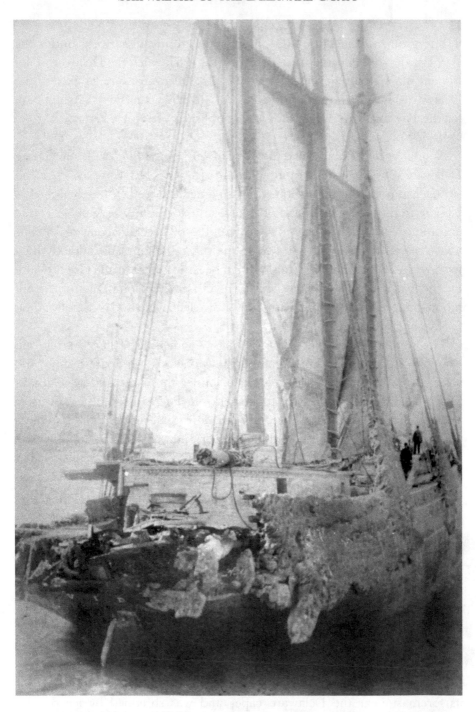

Rain, snow, wind and ice were the enemies of ships in the 1700s, 1800s and early 1900s. This ship was damaged in the Blizzard of 1888, which caused vessels to crash together at the breakwater. *Courtesy of the Lewes Historical Society*.

Even in fair weather, however, ships foundered, coming up against shoals and beaches and hanging fast. Sometimes they could be floated off with the assistance of tugs or other ships. Sometimes the cargo was salvaged, and the ship was either stripped down to its hull to use as building materials or left to the elements. Many a house in Lewes was built with beams that were recycled from shipwrecks.

PIRATES AND PRIVATEERS

The valuable cargo moving between the colonies and their mother countries served as mouthwatering bait for pirates and privateers, who moved up the coast from the West Indies to capitalize on the commercial trade and the vast number of barren areas that offered hideouts. These men were not necessarily pirates flying under a black flag. War turned enemy ships into "prizes," available for the taking, even if the ship was in neutral water. Plundering the cargo, forcing the crew into service—which was known as "impressment"—and taking or wrecking the ship was all a legitimate part of warfare. The English and Dutch preyed on the Spanish and the French and vice versa. Those fed up with the military but still attracted by the loot joined rogue buccaneers. In some cases, a simple repentance was enough to gain the Crown's pardon. No doubt the sovereigns wanted to benefit from a pirate's skills.

In 1672, there were reports of pirates descending upon Lewes and running off with so many goods that the price of liquor was raised to offset the losses. In 1698, Canoot, a French pirate, captured a Philadelphia sloop near Cape May, boarded it with fifty men and sailed to Lewes to loot the town, picking each home so clean that one resident complained there was nothing left to wear. They even took the village carpenter as their prisoner.

While the landings usually resulted in someone being robbed, there were those who benefited from the pirate visits, which gave colonists the opportunity to barter for black market goods at a lesser price than if they dealt with government merchants. An incensed England warned the local governments to take care of the problem.

In 1699, a ship with about sixty pirates struck again in Delaware. The men were supposedly part of William Kidd's crew. Indeed, Kidd, Blackbeard and Avery became household names in Lewes. To halt the activity, the government offered pardons to the pirates in exchange for good behavior—especially if officers found the pirates with a big booty—but being bad must have been a

lot more fun than being good, because in 1709 Lewes was again threatened by pirates. A ship hovered off the coast, waiting for merchant ships to cruise down the river. Fortunately, a messenger in a boat, manned by four oarsmen, traveled up the river to warn ships of the impending plunder. The government began offering financial incentives for anyone who provided information leading to a pirate's capture. Coastal town residents were encouraged to have weapons ready to defend themselves.

Pilots, so necessary to navigation, became a liability. Pirates entered the Delaware Bay under English colors and signaled for a pilot, whom they would capture. The pirates would then use the pilot boat as a ruse. When vessels signaled for navigation, the pilot boat would unload pirates onto its decks. Witness this account from the *Pennsylvania Magazine of History and Biography*, volume 32:

> *Spaniards from a captured pilot-boat, on Sunday, July 12, 1717, went ashore on the plantation of Edward Liston in New Castle County, about four miles from Bombay Hook, near the present Woodland Beach. Armed with pistols, guns and cutlasses they rifled Liston's house, taking even furniture and clothing, a negro woman, her two children and a negro girl. They then clapped a pistol to Liston's breast and compelled him to accompany them to the plantation of James Hart, who observing their approach, secured his doors and with a gun offered resistance. They fired upon Hart, and after wounding his wife and threatening to burn his house, he surrendered and his home was looted. In the evening of the same day, they captured the pilot-boat of one John Aries.*

To protect their property, many merchants and local governments outfitted their own privateer vessels. The *Pandour* was an American privateer ship built in Philadelphia in 1745 and commanded by William Dowell, formerly captain of the privateer schooner *George*. On January 21, 1746, the *Pennsylvania Gazette* ran this notice:

> *Now fitting out for a Cruizing Voyage against his Majesty's Enemies, and will sail in two Weeks THE SHIP PANDOUR, William Dowell, Commander; Burthen about 300 Tons; to carry 24 Carriage Guns, nine and six pounders, 24 Swivels, and 30 Brass Blunderbusses, with 150 Men, is a new Ship built for a Privateer, and in every way completely outfitted for that purpose.*

With the possibility of earning one hundred pounds on a single cruise, many men chose privateering over the navy, and it was not unusual for indentured men to run away and join a privateer ship.

Merchants demanded that the government do something about the piracy, and in May 1748, a man-of-war was assigned to the Delaware Bay. Unfortunately, the ship was damaged in an encounter with the French on the way to its station, and it was subsequently dismantled for repairs. A Spanish brigantine, the *Saint Michael*, chose that opportune time to capture a sloop off the Delaware capes and then a pilot boat. Spotting booty anchored off New Castle, the Spanish captain, Don Vincent Lopez, plotted to capture the ship, loot and burn the town and continue up the river, stopping to do the same at other port towns. An Englishman, who had been impressed for service, dove overboard to warn the town just before the pirate ship arrived flying English colors. Although hard to convince, the townspeople and merchants decided to err on the side of caution and fire upon the ship, which made a hasty retreat for Reedy Island, located between Port Penn, Delaware, and Salem, New Jersey. Increased vigilance on the part of the military and the townspeople helped discourage the raids toward the end of the 1700s, and pirates made for more hospitable waters.

THE CURSE OF THE MOON CUSSERS

While pirates and privateers used the sea to rob victims, another group of nefarious thieves used the land to deceive their seagoing prey. They were known as wreckers, sea scavengers and moon cussers because an illuminating full moon would thwart their shady plans. No matter the name, they were notorious groups of thieves who enticed passing ships to founder by pretending to be another ship or a lighthouse. On dark, moonless nights, these rogues lit lamps and either walked them along a high point near the water's edge or tied the lamps around an old mule, called a nag. (Some say that is how Nags Head, North Carolina, got its name.) Captains would mistake the lights for a ship that was closer to shore, and they would redirect their course, turning to better hug the coastline.

Wreckers were credited for shipwrecks along rural coasts up until the late nineteenth century, but there are experts who dispute the story, maintaining that captains would avoid another ship instead of coming closer to it. Still,

captains in the seventeenth and eighteenth centuries had to rely on compasses, quadrants and lead lines, and in Delaware staying close to shore was part of the navigation process when the goal was to reach Cape Henlopen.

Wreckers in Delaware had a lighthouse advantage, according to Dale Clifton, founder of the DiscoverSea Shipwreck Museum in Fenwick Island, who tells the tale during tours of the museum's artifacts. Ships from the south, seeking the mouth to the Delaware Bay, looked for two lighthouses: the Assateague Lighthouse, built in 1833 on the Virginia portion of Assateague Island, and Cape Henlopen Lighthouse, completed in 1767. After passing Assateague, navigators kept their eyes trained for Cape Henlopen, where the ship had to make a sharp turn in order to enter the Delaware Bay.

To mimic a lighthouse, wreckers placed a fifty-five-gallon metal drum with a hinged door on a high point somewhere between the two lighthouses. They would then open and close the door to resemble a lighthouse's beacon. Upon spotting the light, navigators would wonder if they were about to pass the Cape Henlopen Lighthouse. Those who fell for the trap turned the ship, which would then founder on a shoal or rocks. The thieves rowed out to the ship to steal the goods. Back on the beach, they stripped the dead of possessions and quite possibly killed those who managed to survive the ordeal.

The unscrupulous band's activities gave rise to a ghost story, known as "Molly on the Dunes" or "The Lamp Lady." Ed Okonowicz, author of *Terrifying Tales 2 of the Beaches and the Bays*, often tells ghost stories at historic landmarks, such as the Indian River Life-Saving Station, situated north of the Indian River Inlet in southern Delaware. Okonowicz on one occasion was telling the story of the mysterious ghost of a woman with a lamp when a volunteer at the station told him the ghost had a name: Molly McGwinn.

Molly was either an indentured servant or a relative of a family of sea scavengers. While running errands in Lewes, Molly met a visiting Englishman, and of course, it was love at first sight. The couple met secretly until he announced plans to sail back to England for a visit. When he returned, he promised, he and Molly would marry. As a symbol of his pledge, he gave her half of a coin and pocketed the other half.

Six months went by and there was no sign of Molly's fiancé. The heartbroken Molly resigned herself to living in the company of scalawags. One night, the wreckers gathered to intercept an expected merchant ship. Molly dutifully played her part in the ruse, flashing the light to lure a ship to shore. The sailors took the bait, and the ship plunged onto the

rocks and splintered apart. After the men unloaded their plunder on the beach, Molly noticed an odd object gleaming among the goods. It was a chain with half a coin hanging from it. Horrified, Molly clambered down the beach, running from one washed-up corpse to another. She finally stumbled upon her dead fiancé. Crazed with guilt and grief, Molly fled into the sea and drowned herself.

In 1876, surfmen working at the Indian River Life-Saving Station reported seeing a light bobbing in the water. Some claimed that it was carried by a woman in a white dress. The lantern remained lit even when the waves consumed her. Nothing was documented, but the legend has been handed down through generations.

COIN BEACH

When Dale Clifton was fourteen, his mother, a librarian, would bring him books about pirates and buried treasure. The Milton, Delaware native caught the bug. He had heard that coins frequently washed up along the Delaware coastline in an area dubbed Coin Beach. After a year and two months of searching, Clifton found his first coin. "It revealed the image of George III," he recalled. "I was the first person to touch that coin after all those years; I felt I was shaking hands with history." Since then he's found at least 200,000 coins.

Coin Beach, located on a stretch of coastline in Delaware Seashore State Park, is just north of the Indian River Inlet, which links the Indian River Bay with the Atlantic. People have been finding coins there as far back as 1878, when a tourist found two gold pieces and a Spanish coin. However, the shoreline likely received its nickname after February 22, 1937, when workers from a local Civilian Conservation Corps camp found eighteenth-century English pennies and half-pennies in the sand. There were so many coins on some occasions, according to the tale, that workers collected them in buckets.

Not long afterward, Major Lindsley L. Beach, a retired army officer, and two friends found an old empty sea chest bound in copper. Before they could nab it, the waves embraced it and pulled it back down. He later found a coin dated 1749.

But what is the origin of the coins? Although treasure hunters have found some Spanish and French coins, the bulk are British, minted during

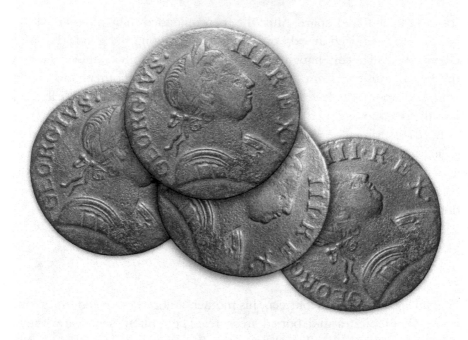

The area known as Coin Beach earned its name from the coins that washed ashore after storms. Many are thought to have come from the *Faithful Steward*, which wrecked on September 2, 1785. *Courtesy of DiscoverSea Shipwreck Museum.*

the reigns of George II (1727–1760) and George III (1760–1820). Some maintain that the money comes from the *Three Brothers*, which foundered in 1775. Not much is known about the British ship, which was said to have been stuffed with copper, silver and gold coins either to pay British soldiers in Pennsylvania or to offset the shortage of coins in the colonies. During a hurricane, the ship was blown onto a sandbar, spilling its cargo of more than five thousand gold rose guineas. Estimates put the loss of life at between 200 and 250.

Others point to the *Count Durant*, a French brigantine that wrecked in 1783. According to Judge Richard S. Rodney, a Lewes historian who was interviewed for a 1954 newspaper article, the *Count Durant* carried five casks of silver coins that included French crowns, Spanish pieces of eight and English copper coins. A note on the wreck in *Reports of Cases Adjudged in the Supreme Court of Pennsylvania* bears him out, reporting that the brigantine had 5,285 French crowns and 1,580 pieces of eight. But in that document, it is

noted that the ship's captain, Forenay, removed the money by boat and took it to Philadelphia, although one wonders if he could have removed all of it.

Most likely, the bulk of the coins are from the *Faithful Steward*, which went down on September 2, 1785. The ship left Ireland with 249 passengers and crewmen. One evening, the vessel hit the shoals off the Indian River Inlet.

Only sixty-eight would survive.

THE TRAGEDY OF THE *FAITHFUL STEWARD*

On Thursday, September 1, 1785, the ship *Faithful Steward* glided toward Cape Henlopen. The excitement on board must have been palpable. The ship, which had departed Londonderry, Ireland, on July 9, 1785, was at last nearing Philadelphia, its final destination. The ship was behind schedule, perhaps owing to dead seas that slowed the ship's progress. Or maybe it was because the ship had gone too far south. Either way, Captain Connoly M'Causland—sometimes written as Connolly McCausland or Connoly M'Casland—wanted to reassure his passengers with a party.

It was a close-knit group, and not just because they had spent so much time together at sea. The 249 passengers included nearly 50 members of the Elliott family, as well as a significant number of people from the Lee, Stewart and Espey families. Mary and Hugh Stewart Espey and their five children were to join their two oldest sons in Pennsylvania. Also waiting in America for his family was John Elliott, who had encouraged his father, two brothers and five sisters to come live with him. More than 100 passengers were women and children.

Most of the passengers were eager to begin life in America, "a country where the banner of freedom waved proudly; a country where heroes lived; where genius expanded to full perfection; where every good was possessed," according to James McEntire, whose personal account of the shipwreck appeared in the August 30, 1831 edition of the *Meadville (PA) Courier* and the February 4, 1881 issue of the *Crawford (PA) Journal*. Then twenty-two, he was also a passenger on the *Faithful Steward*. What he experienced in the next twenty-four hours would dispel his hopeful conviction.

The *Faithful Steward* was a three-masted, 150-foot-long vessel owned by John Maxwell Nesbitt, James Campbell and William Allison, who were all Philadelphia merchants. In addition to its passenger cargo, the ship also

carried their belongings and about four hundred barrels of British pennies and half-pennies.

In 1785, the United States had no mint of its own, and it depended on European coinage. Many of the pieces were underweighted and thus deemed unsuitable for Britain. Yet the British citizens who were pressed to toss their coins in the pile were disgruntled. The war with the colonies was still fresh in their minds, and they resented handing anything over to them. To spite the king, they punched a hole through his image on the coin or snipped the coin in half. Since the value was strictly based on the coin's weight, the coin was still usable.

The festival to celebrate the ship's impending arrival was punctuated by the announcement that a young couple was celebrating an anniversary. After spending months in cramped, dark quarters on an overcrowded ship, with unappetizing food that was nearing the spoilage point, the passengers looked forward to some levity. So, apparently, did the captain and the first mate, Mr. Standfield, who joined the fête. McEntire recalled that the party possessed "music, dancing and every description of mirth succeeded. A most intemperate carousal was the closing scene of the day. Among the intoxicated were the Captain and the first mate, who were borne insensible to their cabins."

The crew and the passengers went to sleep, eagerly awaiting the morning. Some would not live to see it.

By 10:00 p.m., the wind had whipped itself into a fury, making the sails crack. Hurricane activity had been brisk that September, storms hammering the coast within just weeks of one another, and it appeared that the ship was in for a formidable storm. Second Mate Gwyn on the *Faithful Steward* decided to take soundings. To the crew's surprise and horror, the ship was sailing in just four fathoms (twenty-four feet) of water. It needed thirty feet to successfully remain afloat. He frantically swung the wheel, but the ship struck the Mohoba Bank, located just north of the Indian River Inlet. Below deck, passengers lurched awake in their bunks. The impact knocked two small children to the floor, killing them instantly.

In the ensuing panic, mothers, nervous themselves, would have attempted to soothe screaming children; men would have demanded answers. In the quest to get topside, some would fall and struggle to get up as their fellow passengers stepped over or on them.

As morning dawned, the crew and passengers could see that they were just 100 to 150 yards from shore. It might as well have been a hundred miles.

The waves were so high that they were careening over the deck, and many of the passengers aboard likely could not swim. The crew lowered longboats into the water, but the sea whisked them away, pounding them to pieces.

Pinned to the bank, the ship took the brunt of the punishing wind and waves like a modern-day punching bag. The first crack must have caused widespread terror. The ship started to break apart. Splintered wood toppled into the hungry surf. To keep the ship from falling onto its side, sailors cut away the ship's masts—only they neglected to cut the rigging. The ship rolled, tossing some people into the water.

The captain and some crew members dove into the ocean and swam for shore, while passengers struggled to hold on to something—anything—their screams for help piercing through the storm's howls. Mothers lost babies, husbands were separated from wives and brothers lost sight of sisters.

Meanwhile, a French brig headed to Philadelphia was caught in the same tempest, and it foundered within sight of the *Faithful Steward*. The crew managed to launch their lifeboats. Some accounts say that the men survived; others report that they were never seen again.

The horror continued all day as the *Faithful Steward* continued to break apart, forcing some people into the water. McEntire decided to take his chances. He climbed out on the mast, now tipped into the water, and dove into the waves. As he reached the beach, a sailor waded out and helped him to shore.

Instead of landing in America, however, he thought he had landed in hell. Local residents had flocked to the beach not to rescue and aid the survivors but to rip the clothes and jewelry from the bodies of the beached passengers. He witnessed them "stripping the lifeless body of their clothing, snatching everything of apparent value, heaping the plunder on wagons and hauling it away." They were there only to "plunder till they could plunder no more." When the scavengers came upon someone dead and naked or alive, their eyes dulled with disappointment. There were stories of brigands cutting fingers off to better slip off the rings.

The exhausted and dispirited McEntire found his father alive on the beach. The two collapsed, drained and stunned. Even then, they could still hear the piteous cries for help coming from the water. McEntire later found his sister, but his mother, brothers and another sister were lost.

Only sixty-eight people survived the catastrophe, although the exact number is unknown as some may have later died of the injuries they sustained. Of the one hundred women and children, just seven were saved. An article in the September 12, 1785 edition of the *Pennsylvania Packet* reports

that "the rest perished with the ship, in sight of the miserable survivors, who were the unhappy witnesses."

The sun rose on a beach littered with bodies, which would later be buried where they lay or in common graves. Several days later, while strolling the streets of Lewes, McEntire spotted a man wearing a vest that had belonged to a member of McEntire's family. An incensed McEntire demanded its return and a fight ensued. The garment was later returned to McEntire.

The immigrants with such high hopes were broken and, in many cases, penniless. But most went on to make a life in America. Still, those who'd left their hearts on the Mahoba Bank, which the Irish called "Mahogan's Bay," inspired a ballad:

> *The Elliotts and the Lees*
> *And Stewarts of great game,*
> *They may lament and mourn*
> *For the lands they've left behind.*
> *They may lament and mourn*
> *As long as they have days,*
> *For the friends and relations*
> *Lie in Mahogan's Bay.*

Today, after a storm, the treasure seekers hit Coin Beach, perhaps equipped with metal detectors. Some might strike gold. Yet few may realize that their gain came from a loss of life that remains one of Delaware's most ghastly maritime disasters.

THE DISAPPEARANCE OF *DE BRAAK*

The story of the *Faithful Steward* for obvious reasons continues to pop up in newspaper and magazine articles about Delaware shipwrecks. On a national and international basis, however, its celebrity status has been eclipsed by the tale of *De Braak*. It is not the loss of life that makes this wreck so famous, although the ship took down members of the crew, including its captain, James Drew. It is the rumors of treasure, which spurred salvage companies to risk their lives and their ships to find *De Braak*.

De Braak, which means "The Beagle," had mysterious origins. By most accounts, it was built in 1781. Donald Shomette (author of *The Hunt for HMS*

De Braak: Legend and Legacy), however, is certain that it was built prior to that date. Some also maintain that it was built in America or that it was French at one time. Indeed, there are those who believe that *De Braak* was built as an English privateer, captured by the French and then sold to the Dutch.

What is known is that *De Braak* appears in Dutch navy records as having been purchased by the Admiralty of the Maas, one of the five independent state navies in the Netherlands. A single-mast cutter, the fast ship was the type that the Dutch might use as a privateer or a naval dispatch boat.

De Braak is a prime example of European countries' propensity in the 1700s and 1800s to claim an enemy vessel as a prize. In 1795, the 255-ton ship was anchored in Falmouth, an English port, to take on provisions when war was declared between England and the new Dutch Batavian Republic, which was aligned with the French revolutionary government. On January 20, 1795, England forbade Dutch ships to leave English ports. There were more than a few alongside *De Braak*, including Dutch warships and merchantmen. More than a year later, England claimed the Dutch warships in its ports.

The British converted *De Braak* into a two-masted brig, a fast sloop-of-war. The ship's classification has led some to maintain that the ship should have the letters "HMB" (His Majesty's Brig) before its name rather than the more commonly used "HMS." Others say *De Braak* is aptly named for His Majesty's Sloop of War.

During the conversion, *De Braak* also received a flashy copper sheathing on its hull, which would protect it from shipworms, common in tropical environments, and guard the hull against barnacle growth, which can affect

When the British captured the Dutch ship *De Braak*, they transformed it into a cutting-edge warship with two long guns and fourteen carronades (short, powerful guns). *Courtesy of the State of Delaware Department of Historical and Cultural Affairs.*

the vessel's speed. A new device, a Brodie-patent stove, let the cook roast, bake and boil. *De Braak* also received fourteen carronades, shorter and more powerful guns that were considered cutting edge at that time. The twenty-four-pound ball could crash through a ship's wooden hull like a knife slicing through butter. The ship was also armed with two small long-barreled guns.

In June 1797, Captain James Drew took command of the vessel. Born in 1751, Drew was just thirteen years old when he and his brother, John, entered the Royal Navy. Some have called him ruthless, and certainly his character has come under some scrutiny. By 1787, he became post captain aboard the HMS *Powerful* but, for some unknown reason, was quickly demoted to several small sloops of war. He retired and fathered an illegitimate child by a housemaid, after which he scampered to America to marry Lydia Watkins, part of a New York mercantile family. Drew sought to return to service, but he did not receive an offer until after a mutiny in the Royal Navy. To make peace with the mutineers, who protested poor living conditions and impressment, the Royal Navy hung those officers deemed unethical or brutal, which left a gap in its officer lineup. Drew was ready to help fill it.

In March 1798, *De Braak* was ordered to escort a ten-ship convoy of American and English merchant ships. The group set out to eventually join *St. Albans* and that ship's convoy. On April 1, off the Azores, *De Braak* left the convoy to chase what appeared to be a "strange sail." In reality it was the HMS *Magnamine* of the Royal Navy, and the privateer *Victory*, a French prize. A storm further separated *De Braak* from the convoy.

The location of *De Braak* for the next seven weeks is an exercise in guesswork. Some say Drew made for the Caribbean, where he snagged Spanish ships laden with treasure. Did Drew slip away from routine convoy duties and set sail for the Caribbean to seize rich prizes? Probably not. Shomette writes that Drew was an officer with thirty years of service; he would not have ventured that far afield. In fact, he likely arrived at the Delaware capes shortly after *St. Albans*. Yet sometime during *De Braak*'s Atlantic crossing, Drew did capture a prize, the Spanish ship *Don Francisco Xavier*, which was carrying copper and cocoa beans, both highly prized commodities to warring nations. A portion of *De Braak*'s eighty-six-member crew, known as the "prize crew," moved aboard the captured vessel to sail it. At least fifteen Spanish sailors were placed in the brig.

On May 25, 1798, *De Braak* and its prize entered the mouth of the Delaware River. As was the custom, the ship signaled to the pilot boat *Friendship*, and pilot Andrew Allen came aboard to guide *De Braak* up the river. Gilbert McCracken watched from his own pilot boat. As Allen took

control of the ship, a jovial Drew reportedly nodded to the Spanish ship and said, "I've had good luck."

Drew's luck, however, was about to run out. As *De Braak* headed to Lewes to pick up fresh water, the weather took a turn for the worse and the wind picked up. Allen ordered the crew to take in sails. Drew cursed at him and countered, "You look out for the bottom, and I'll look out for the spars."

Anchored near Cape Henlopen Lighthouse, the crew lowered the six-oared cutter to the water for the landing party. Suddenly, a violent squall hurled *De Braak* onto its side like a child tipping a toy boat. Carronades undoubtedly careened across the deck, and water gushed through open hatches. There was no time for the men below deck to make it topside. The crew on the Spanish ship must have watched in open-mouthed astonishment as *De Braak* slipped under the waves and settled eighty feet below the water. The topgallant mast marked its grave like a tombstone. Forty-seven men went down, including Captain Drew, whose body washed up on the beach and was buried in the graveyard at St. Peter's Church in downtown Lewes. Allen, who suffered a broken leg, managed to make it ashore. According to legend, three surviving Spanish prisoners floated ashore on the captain's sea chest, which is now located in the Zwaanendael Museum. After paying for room and board with gold coins, they alluded to a lost fortune. And so the legend began.

The British made several attempts to raise *De Braak*, but each failed. Over time, the vessel seemingly evaporated, just another wreck in an area littered with them. Pilot Gilbert McCracken, however, had noted on paper where he thought the ship went down. He slipped the paper into the family Bible, and his son, Henry, who also became a pilot, passed on the information to his children. Meanwhile, the myth and mystery surrounding *De Braak* mushroomed. J. Thomas Scharf, in his book *History of Delaware: 1609–1888*, mentions *De Braak*'s cargo of gold, silver, diamonds, coins and metals as if its existence was a known fact.

Efforts to find *De Braak* and its rumored hoard seemed cursed. In 1867, Captain Charles Sanborn insisted that his research indicated the ship did indeed hold a treasure. He died before he could launch an effort to find the ship. Samuel McCracken, Gilbert's grandson, claimed that *De Braak* had a treasure worth $52 million. He received backing from Connecticut-based International Submarine Company, but the search was futile. As was a hunt led by Dr. Seth Pancoast, a Philadelphia teacher, and the Merritt Wrecking Company of New York in 1889. Diver and author Gary Gentile documents

fourteen attempts between 1880 and 1981, including one operation named HMS DeBraak Salvage Company.

The failed missions gave rise to the story of the Bad Weather Witch, who for centuries kept opportunists from finding *De Braak*. In the play *Delaware Ghosts*, author and folklorist Kim Burdick created a ditty for the sea hag to sing: "Don't touch the *De Braak* ye vermin and swine. Her bow is my cradle, her treasures are mine!" In 1935, Charles Colstad and Richard Wilson were so frustrated at their failure to find *De Braak* that they made an effigy of the witch, set it aflame and tossed it overboard from their ship.

By 1980, Mel Joseph got involved. The Georgetown, Delaware businessman had helped finance Mel Fisher's search for the *Nuestra Senora de Atocha*, which sank in 1622 off the Florida coast. The ship's glittering cache was worth at least $6 million, and the "mother lode," found in 1985, included silver, coins, emeralds and gold, some of which is on display at the Treasures of the Sea exhibit at Delaware Technical and Community College in Georgetown, Delaware, and in the DiscoverSea Shipwreck Museum in Fenwick Island, Delaware. Joseph backed a project led by Seaborne Ventures, Inc. Work off Dewey Beach yield an impressive collection of coins—possibly from the *Faithful Steward?*—but no timber and no evidence of *De Braak*.

In 1984, it was Reno, Nevada–based Sub-Sal, Inc.'s time in the spotlight. The salvage operation had the benefit of new side-scan sonar equipment. By April, the wreck had been discovered and verified based on a recovered anchor, carronade, dated coins and a ring belonging to James Drew.

However, none of the retrieved artifacts that followed indicated that there was treasure to be had. Running out of cash and faced with criticism for unprofessional salvage operations, Sub-Sal president Harvey Harrington sold the company to a New Hampshire investment group led by L. John Davidson. Like Harrington, Davidson found scattered coins, much of which amounted to the sailors' pocket change, and some jewelry but no mother lode. He decided to look underneath the hull.

It was August 11, 1986. Plans called for the hull to be shifted onto a steel-and-wood cradle, but the cradle was improperly rigged, and foul weather was approaching. (The Bad Weather Witch strikes again.) Davidson decided to forego the device and use cables. In his book, Shomette dramatically documents the hull's raising. While the crowd watched and cameras whirred, the hull broke the surface. A friction brake failed, and the hull hovered at the surface, pummeled by the waves. The lift resumed, and the hull rose vertically, spilling cannonballs and the interior partitions into the sea.

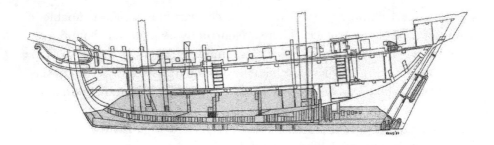

The highlighted section on the drawing of the *De Braak* indicates the area of the hull brought up during salvage efforts in the 1980s. *Courtesy of the State of Delaware Department of Historical and Cultural Affairs.*

Watching archaeologists gasped with horror as artifact-laden sludge slid off the hull's surface and cables sliced the hull's sensitive sides.

Photographer Marc Clery and other members of the media stood on a boat, poised to capture the hull's appearance. It was night, and fifteen-foot waves turned the boat into a roller-coaster ride. Photographers and the camera crew, many of whom were violently seasick, were forced to time their shots between swells. Clery that night dreamed that the wife of *De Braak*'s captain was haunting him. The next day, most photographers wound up with blurry photographs. Thanks to good timing and careful processing, Clery produced an eerie black-and-white photograph of the exhumed hull resting on a barge with Davidson, director of the salvage effort, standing beside it. A trail of crane smoke hovers over the hull like a genie released from his bottle. A shaken Davidson told Clery it looked like a ghost.

For two years, divers would retrieve more than twenty thousand artifacts, ranging from footwear to toothbrushes to cannonballs. But the $2.5 million effort found no cache of gold, no silver and no gems. In 1992, the State of Delaware paid Sub-Sal $300,000 for the hull and the artifacts, which include ammunition boxes (still cradling rows of shotgun-like projectiles); pearlware; earthenware; the mourning ring that Captain Drew wore to honor his brother, John, who died at sea five months before James Drew; muskets; pistols; and such everyday items as a glass bottle marked "Ketchup," a concoction consisting of cloves, spices, mushrooms and stale beer that was used to cover up the flavor of the grim food rations on board.

While some of the items are on display in the Zwaanendael Museum in Lewes, the bulk is located in a government warehouse in Dover, waiting for

a day when Delaware may open a full-scale maritime museum capable of holding most of the artifacts. There are currently no plans for that project.

For now the hull rests alone, about forty minutes away, in a shed near Cape Henlopen State Park, where it is bathed with water three times a day to keep it from drying out and disintegrating. It is a short drive from the monument that marks Drew's grave, where some claim to have seen his ghost rise to search for his crew. It is also not far from *De Braak*'s original resting place on the muddy bottom of the ocean.

There might be no treasure, but the myth lives on. Legend has it that on a moonlit night you can see the ghost ship sailing near Cape Henlopen.

LIGHTHOUSES, LIGHTSHIPS AND LIFESAVERS

AN ENDURING ICON

Symbols of stability and safety, lighthouses became vital as shipwrecks increased. As early as 1716, a rustic lighthouse, fueled by whale oil, may have stood on Cape Henlopen. But the main lighthouse given that name—which would take on legendary proportions—was completed in 1767. (The lighthouse may have been lighted as early as 1765, when the tower was still under construction.)

One of the first lighthouses in the original thirteen colonies, the Cape Henlopen Lighthouse was preceded by Sandy Hook Lighthouse (1764) in New Jersey; the New London Lighthouse (1760) in Connecticut; the Beavertail Lighthouse (1749) in Rhode Island; the Brant Point Lighthouse (1746) on Nantucket Island; and the Boston Harbor Lighthouse (1716), which used a cannon as its foghorn.

Although a definable Delaware landmark for more than a century, the lighthouse was not built by Delawareans. A group of wealthy Philadelphia merchants, who wanted to make access to their city safe and identifiable, raised funds for the lighthouse via a lottery and the sale of lighthouse bonds. Land was deeded to the state of Pennsylvania. In 1789, lighthouse supervision was moved from the states to the federal government.

Made from granite brought down from northern quarries, the lighthouse was built on the highest hill on the cape. Accounts of its size differ, ranging from 69 to 87 feet tall. Walls were 7 feet wide at its base and 4 feet wide at the top. The lighthouse at that time was about a quarter-mile from the

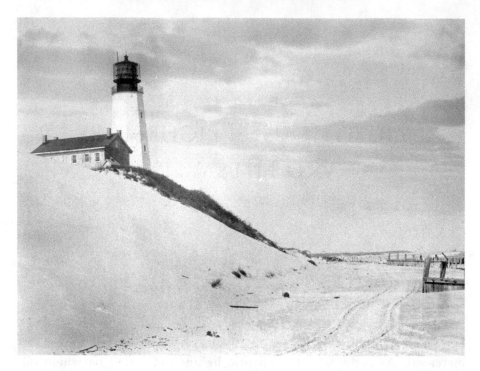

The Cape Henlopen Lighthouse, completed in 1767, was a beacon for more than 150 years. It marked the entrance to the Delaware Bay. *Courtesy of the Delaware Public Archives.*

water atop a sandy hill and about 130 feet above sea level. Initially, the system of eighteen lights and reflectors was lit by whale oil. When that proved too expensive, keepers used lard and mineral oil. In 1855, the lighthouse received a first-class Fresnel lens that extended its light to more than twenty nautical miles.

During the Revolutionary War, Continental forces used the lighthouse to keep watch for the British. They did not need to look far. Rather than unload soldiers on the shore, the Royal Navy blockaded the entrance to the bay. Blockaders, however, need supplies, and in April 1777, HMS *Roebuck*, a British frigate, dropped anchor in the bay. The forty-four-gun, 140-foot-long ship was notorious around the coast. It had long harassed the residents and impressed sailors for service in the Royal Navy. Many smaller vessels were captured, scuttled or burned.

The *Roebuck*'s foraging party wanted to buy cattle from the lighthouse keeper, an intrepid patriot named Hedgecock. The keeper drove his herd into the woods and retorted that he would give the British "bullets instead of

beef." The angry British burned the keeper's quarters and the lighthouse's wooden staircase in retaliation, forcing Hedgecock to follow his herd into the woods to save his life. Since the *Roebuck* has no record of this account, some say that it was a careless Hedgecock who actually started the fire by knocking over a lamp. It was not until 1783 or 1784 that the repaired lighthouse was back in operation.

During the War of 1812, yet another British blockade took up residence at the mouth of the bay. To thwart the enemy, the residents extinguished the lighthouse's light and removed buoys and channel markers, causing British ships to encounter shoals and rocky traps hidden below the surface.

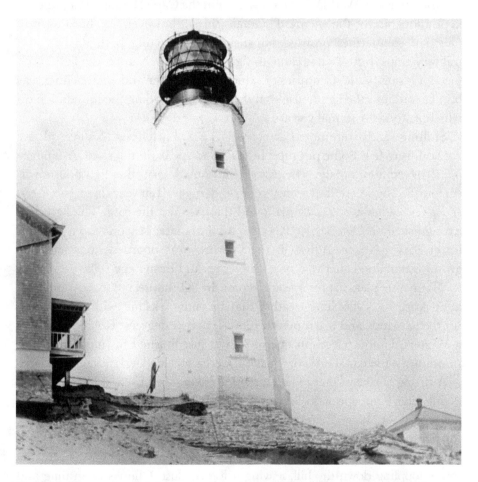

Over time, the weather and shifting sands started to erode the foundation on which the Cape Henlopen Lighthouse sat—a dangerous threat to the structure. *Courtesy of the Delaware Public Archives.*

In 1825, the lighthouse received a companion, the Cape Henlopen Beacon, a forty-five-foot-tall masonry tower located closer to the town of Lewes. It was dismantled in 1884 when the sea threatened its foundation. Indeed, on January 9, 1884, angry, wind-tossed seas started to lap at the building. By 4:00 a.m. the light keeper, Joseph Hall, and his family were trapped atop the screw-pile structure. The sea had washed away the exterior staircase and was now hungry for the whole building. Surfman Maull of the lifesaving station, who was on patrol, was at a loss to help without equipment. When the tide ran off, the rescuers waded to the house and used a sixteen-foot ladder to rescue the family. Throughout the threat, the keeper had stayed at his post.

Once again, in World War II, the keeper at the Cape Henlopen Lighthouse kept a lookout for the enemy. The main threat, however, was hard to spot. German submarines prowled off the coast, targeting both civilian and military ships. But when it came to fighting Mother Nature, the lighthouse faced a losing battle. Centuries of wind, bad weather and encroaching seas had carved into the lighthouse's sandy platform, eroding the foundation on which it stood for so many years.

Shifting sands were noted as early as 1788, but efforts to stave off the erosion were few. Some put their heads, so to speak, in the sand. A January 5, 1914 edition of the *Washington Post* noted that the lighthouse was surrounded by water "but seems to be no danger." Ten years later, the *Report of the Commissioners of Lighthouses* found that was not the case. The light was extinguished on October 1, 1924, and an automatic beacon atop a skeleton tower took its pace. Although the building was boarded up, the sandy grounds remained an idyllic spot for picnics and Easter egg rolls.

There were pleas to preserve and repair the lighthouse, but those went mute after April 13, 1926. The weather that morning was fair with diminishing northeast winds and a temperature of sixty-two degrees. Roland Webster, a Western Union telegraph operator, had just finished his lunch and was standing on the canal bridge, which offered a scenic view of the lighthouse.

A strong northeast breeze had picked up along the beach, rolling in a high spring tide that repeatedly nipped at the hill that supported the teetering lighthouse. At about 12:45 p.m., Webster blinked. When he opened his eyes, the lighthouse was gone, as though it had vanished during a magician's trick. The ebbing foundation had finally given way just enough that it sent the tower toppling down the hill, leaving a fog of dust. Chunks of granite and rubble were scattered along the coast, and many a fireplace in the Lewes and Rehoboth area was later said to be made of old lighthouse stone.

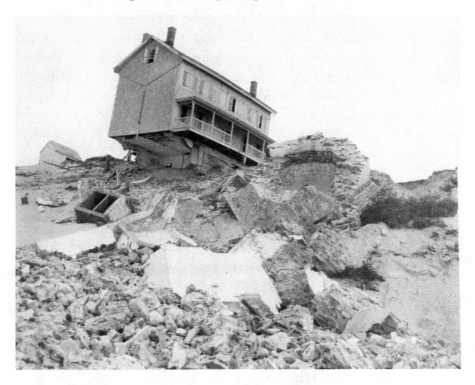

On April 13, 1926, the Cape Henlopen Lighthouse toppled into the sea, leaving a mountain of rubble behind. It's rumored that many fireplaces were subsequently constructed from the rocks, which became collectibles. *Courtesy of the Delaware Public Archives.*

Although it fell in the early twentieth century, the lighthouse's mystique and iconic status has only increased rather than dimmed. The ghost of the structure remains the definitive sign for the entrance to the Delaware Bay, and its image is highly collectible whether in pictures or on postcards.

STALWART SENTINELS

The Cape Henlopen Lighthouse for some time was the only lighthouse in the area, but the need for more beacons was clearly evident. In the nineteenth century, the structures started popping up along Delaware's coast in all shapes and sizes—ranging from the skeletal, cast-iron Reedy Range Rear Light, lighted in 1910, to the classic-looking Fenwick Island Lighthouse, lighted on April 1, 1859, today a tourist attraction.

The operations faced changing governance. In 1789, the U.S. Lighthouse Establishment was launched as an administrative unit of the federal government. The number of lighthouses soared from 70 in 1822 to 256 in 1842. In 1838, Congress divided the Atlantic coast into six lighthouse districts and the Great Lakes into two districts. Each district received a naval officer with a revenue cutter or a hired vessel placed at his disposal. From 1852 until July 1, 1910, the U.S. Lighthouse Board administered the lighthouse system. Then the U.S. Lighthouse Service took over until 1939, after which time lighthouses became the U.S. Coast Guard's domain.

While lighthouses along the Atlantic Ocean, Delaware River and Delaware Bay helped prevent countless disasters, many are ironically known as reference points for the places where shipwrecks occurred. The Ship John Shoal Lighthouse on the New Jersey side of the river, which began operations in 1877, owes its name to the ship *John*, which in December 1797 got mired in the ice near the shoal and broke apart. Happily, the passengers and crew were able to abandon the ship and seek shelter at the village of Greenwich, New Jersey. The cargo—including Swedish iron, sailcloth, Russian sheeting, nails and German toys—was also rescued. Successful salvage aside, the shoal and the lighthouse would take on the ruined ship's name.

Perhaps the most famous Delaware lighthouses still standing are located near the site of the old Cape Henlopen Lighthouse. The oldest, the Delaware Breakwater East End Light, sits atop the Delaware Breakwater, which is frequently mentioned in area maritime lore. One of the first structures of its kind in the Western Hemisphere, the breakwater was designed by famed architect William Strickland, who is better known for his Gothic Revival and Greek Revival buildings, such as the Second Bank of the United States in Philadelphia.

The breakwater included the main 2,500-foot section and an icebreaker pier made of granite rubble. Strickland also designed a lighthouse for the harbor, which was completed the next year. In 1883, workers closed the gap between the icebreaker and the main breakwater, necessitating the removal of the Strickland lighthouse.

The current lighthouse, completed in 1885, stands forty-nine feet tall. The rust-colored tower, which has a classic, conical shape and two railings at the top, complemented the Cape Henlopen Lighthouse's efforts until that structure was abandoned due to shifting sands. From 1963 to the 1970s, the lighthouse was occupied by the Pilots' Association for the Bay and River Delaware. It was maintained, however, by the U.S. Coast Guard. The East End was deactivated in 1996.

The breakwater in the late 1800s was used so much that it was soon considered too small. Indeed, the damage to ships during the Blizzard of 1888 was partly due to the large number of craft anchored there at once. The waves slammed the ships together, splintering wood and shaving off bows. A second breakwater was desperately needed.

Located on a shoal known as the Shears and completed in 1901, the Harbor of Refuge Breakwater held a temporary light until 1908, when a permanent fifty-two-foot structure was built. The light earned the nickname "Belle of the Bay" for its attractive, hexagonal appearance. Permanent, however, wound up being a relative idea. Any lighthouse positioned here is among the most exposed on the Atlantic coast, subject to pummeling waves and punishing winds. Keeper Jack Hill of the Delaware Breakwater East End Lighthouse once saw waves hit the "Belle" so hard that they toppled over the tower. A series of storms from 1918 to the 1920s damaged the lighthouse to such an extent that the U.S. Lighthouse Service dismantled it in 1925.

The current cast-iron caisson Harbor of Refuge Lighthouse was completed in 1926 (the same year that the Cape Henlopen Lighthouse tumbled down). It is a white, seventy-six-foot conical tower topped by a

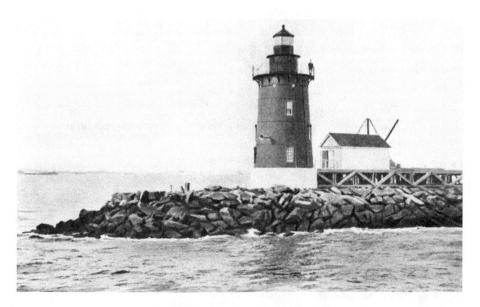

The Delaware Breakwater East End Lighthouse, built in 1885, sits on a breakwater that was built to shelter ships during storms. It was later joined by the Harbor of Refuge Breakwater and its lighthouse. *Courtesy of the Delaware Public Archives.*

black lantern. At present it shines a flashing light every five seconds, visible for nineteen miles. In comparison, its original Fresnel lens had a flash every ten seconds. It, too, has witnessed the fury of the weather. During the coastal storm of March 1962, waves smacked a lighthouse window forty feet above the water.

Built to protect ships, the breakwaters, like the lighthouses, were also the sites of shipwrecks. On January 19, 1891, the British schooner *Mary Rogers* was heading from Trinidad to Philadelphia when it arrived at the Delaware Breakwater during a heavy northeast gale. The ship took shelter at the breakwater, and the crew dropped anchor and took down the ice-crusted sails. Unfortunately, the anchor failed to hold, and the ship smashed into the breakwater. To save themselves, four men dashed from the stern onto the ice-slicked stones of the breakwater. The cook and sailing master lingered behind, gathering their personal items. The cook finally followed, but the sailing master was frozen in fear. He couldn't move, despite his friends' entreaties to take his chances and jump overboard. When the schooner rolled onto its side, waves surged over the boat, and the sailing master desperately clung to the rigging. Like a shark, the surf snatched him from the rigging and spat him into a cavity among the breakwater stones. His friends managed to resuscitate him, but he later died from his injuries.

Farther down the coast, the pretty-as-a-picture Fenwick Island Lighthouse has witnessed similar horrors. The lighthouse sends its beacon out toward the hazardous Fenwick Island Shoal, where shipwrecks increased to such an extent that Congress in 1856 authorized its construction on the Delaware-Maryland border.

The federal government, which selected the ten-acre site for its elevation, paid $50.00 for the property, which was already home to a landmark. A stone monument, erected in 1751, marks the eastern end of the Transpeninsular Line, the east–west boundary between Pennsylvania's three counties (now Delaware) and Maryland. The Calvert family's coat of arms appears on the south side; the Penn family's coat of arms appears on the north side. Built at a total cost of $23,748.96, the eighty-seven-foot lighthouse served as a beacon and a reference marker between Cape Henlopen Lighthouse to the north and the Assateague Lighthouse to the south.

The Fenwick Island Lighthouse is actually two brick towers, not one. The outer conical tower, which narrows at the top, surrounds a cylindrical tower. Like a nautilus, a cast-iron spiral staircase winds through the inner tower to the watch room, the gallery and the lantern. The lighthouse's Fresnel

light, imported from France, cast its first beam out to sea in 1859. Since the lighthouse required constant supervision, a keeper and his assistant lived in a two-story home on the property. In 1881, a second home was built so the two families had more privacy.

Despite the lighthouse's contributions, wrecks continued to happen on the shoals. The *Brinkburn*—an iron-hulled screw steamer built in 1880 by C.S. Swan & Company in Newcastle, England—wrecked here in 1886. The ship was making its way to Philadelphia in a dense fog when it hit the shoal, which gouged the hull. The crew rowed to safety in the lifeboat, and the *Brinkburn* rolled on its side, leaving its iron hull's ends unsupported. The weight of each end broke the hull in two. The ship at auction fetched $1,050 for the structure itself and $210 for its cargo. Most of the ship was apparently salvaged, leaving just the hull. Twenty years later, on January 20, 1900, the *Sutton*, a steamer built in 1897, was heading from Spain to Philadelphia with a load of iron ore when it hit the shoal. The crew was rescued by the U.S. Coast Guard cutter *Onondaga*.

As was the case with other lighthouses, the need for on-site staff at Fenwick diminished when electricity and automation became the norm. In 1978, the U.S. Coast Guard decommissioned the lighthouse, and a grassroots organization, the Friends of Fenwick Island Lighthouse, lobbied for the federal government to give the lighthouse to the State of Delaware. The original lens returned to its rightful place, and in 1982 the lighthouse was back in business.

Some lighthouses worked in tandem with a range system, which consisted of a rear light that glowed steady and a blinking front light. To find their way, navigators line up the lights. Examples include the Reedy Island Range, where the rear light is still operating. The Reedy Island Range Front Light was first established in 1904, and the lighthouse was completed in 1906. The lighthouse was decommissioned in 1951 in favor of a light tower, which remains active.

Some of the lights along the upper section of the river were established after Congress in 1899 authorized the dredging of the channel to accommodate the drafts of large ocean carriers. Philadelphia was losing business to the deeper waters of New York, Boston and Baltimore, and merchants pressed for the change. The dredging also necessitated the relocation of some lights where the channel was altered. Despite modern technology, many still burn bright into the twenty-first century.

FLOATING BEACONS

Their names often appear in shipwreck accounts: *Overalls, Fenwick Island Shoal, Five Fathom Bank, Brandywine Shoal* and *Delaware*. These are names of perilous shoals, but they are also the commonly used names of the lightships that warned ships to avoid them.

Floating lighthouses, these vessels had beacons affixed to their masts and foghorns, which warned ships to stay clear of dangerous territory in inclement weather. The idea for lightships had its roots in an ancient idea. Romans once placed vessels with burning baskets on board at the entrance to strategic harbors to serve as a signal light and to deter pirates, who could see by the fire that the port was well protected.

The first U.S. lightship took up its mission in 1820 off Willoughby Spit, Virginia. Due to frequent storms, it was moved to Craney Island, near Norfolk, Virginia. Between 1820 and 1983, the United States established at least 116 lightship stations, including those renamed or moved to other locations. Between 1820 and 1950, the government built or acquired 179 ships.

The ships were notorious for their heaving decks and rolling movement, which could make even the most stalwart seaman seasick. Conditions on board were primitive. Things got better when Congress divided the Atlantic into six districts and the Great Lakes into two districts. Like lighthouses, each lightship received regular inspections, which in the case of lightships unearthed poor equipment and low morale. The fleet also lacked any commonality other than their light and foghorn. In 1842, the size of the ships ranged from 40 to 230 tons. By 1855, new lightship designs promoted standardization. Many were painted in signature red and white with the name of the shoal printed in large letters across the sides. Technically, each ship had a number that it kept if it moved to a different station, but most knew the ship solely by its station.

Though they existed to protect others, lightships were sometimes a hazard. They were blown off their stations, ravaged by moving ice and struck by other ships, all of which meant that the area they were safeguarding was exposed. Like any vessel, they were also at the mercy of storms. During a hurricane on August 24, 1893, the lightship at the Five Fathom Bank went down.

In the twentieth century, lightships became a dying breed, too expensive to maintain. By 1927, sixty-eight stations had been replaced by buoys or lighthouses, taken over by Canada or put out of commission. The lightship over Brandywine Shoal, for instance, was replaced by America's first screw-

The lightship *Overfalls* was one of the many specially equipped ships that served as portable, floating lighthouses to protect vessels from dangerous or shallow areas. *Courtesy of the Delaware Public Archives.*

pile lighthouse in 1850. By 1930, the number of lightship stations dropped to thirty and steadily plummeted. The last of its kind, the Nantucket Shoals Lightship, was replaced by a lighted buoy in 1983.

Today, along the canal in Lewes, the *Overfalls* pays tribute to the lightship system. The vessel is also an inspiration; its distinctive red hull appears in paintings throughout the region. Interestingly, *Overfalls* is not one of the four ships that floated above a dangerous shoal—with a depth of just 10 feet—that is located near the mouth of Delaware Bay. (In 1960, a buoy replaced the ship to mark the location.) This 114-foot-long ship, which serves as a museum, was built in 1938 at the Rice Brothers Shipyard in East Boothbay, Maine. Among the last lightships built by the U.S. Lighthouse Service, it was considered cutting edge for its time.

The vessel was stationed at three different locations: Cornfield Point off the Connecticut coast; Cross Rip Station off the Massachusetts coast; and Boston Station off Cape Cod. A December storm in 1970 wreaked structural damage, and the lightship was removed from service in 1971. Given to the Lewes Historical Society in 1973, the ship was renamed *Overfalls* to recognize those that once served on the Overfalls Shoal Station.

On December 7, 2001, ownership of the ship renamed the *Overfalls* was transferred from the Lewes Historical Society to the Overfalls Maritime Museum Foundation. The ship is listed on the National Register of Historic Places.

LIFESAVING AND RISK-TAKING

With the economy's increased dependence on maritime trade and the influx of immigrants to the new country came an increase in shipwrecks. Those who did survive the horrific sinking of a ship might face hours if not days in the water or on an uninhabited stretch of coastline. They died of exposure, injury or at the hands of robbers who waited for victims to wash ashore. Patrolling by foot was the best way to keep an eye out for shipwrecks and survivors. But who would do it?

As early as 1787, colonists along the Massachusetts coast established a volunteer effort to rescue and aid shipwreck victims. It was not until 1848, however, that the Massachusetts Humane Society received money from Congress to erect stations along the Massachusetts coast. Also that year, New Jersey Representative William A. Newell successfully added an amendment to a lighthouse bill that appropriated $10,000 to establish lifesaving stations along the New Jersey coast, south of New York Harbor. The stations were run much like volunteer fire departments, except that there was little to no training and little equipment.

In 1849, Congress approved $20,000 more to expand the service along the eastern coast and on the Great Lakes. A superintendent was appointed for the Atlantic and Great Lake locations in 1853, and station keepers finally received pay.

During the Civil War, attention to the service dwindled. But after the war, maritime trade recommenced with fervor—and so did the shipwrecks. The public put pressure on the government to create an official organization with paid, trained crews.

Congress in 1871 appropriated $200,000 to form the U.S. Life-Saving Service, led by Sumner I. Kimball, who determined that stations should be no more than five miles apart, making it easy for the "surfmen" to patrol on foot. Kimball became the general superintendent of the service in 1878, when the U.S. Life-Saving Service was formally recognized as a separate agency of the U.S. Department of Treasury.

The increase in shipwrecks prompted the formation of the U.S. Life-Saving Service in 1871. Stations were manned by "surfmen" who risked their lives to save others in record-breaking storms. *Courtesy of the Delaware Public Archives.*

In 1876, the Indian River Life-Saving Station opened on a barren stretch of coastline near the sinking of the *Faithful Steward*, which went down just one hundred yards from shore in 1785. The Cape Henlopen Life-Saving Station was also built in 1876, and workers would construct stations in Lewes, Rehoboth Beach, Bethany Beach and Fenwick, effectively covering the mouth of the Delaware Bay and the state's Atlantic coastline.

Each station had a keeper and a crew of six. The team was on active duty from November through April, although the period varied depending on the station and the risk of shipwrecks during that time. While the structures varied in style, many sported a cupola, from which surfmen could watch for ships on clear days. Like men in a modern-day fire hall, they slept in a dormitory and shared housekeeping and cooking duties. The largest room in the station was dedicated to the surfboat, which resided on a carriage with wheels that could be rolled down to the shoreline and launched.

Kimball, a stickler about training, demanded that lifesaving crews regularly practice to become efficient and effective. Pulling the surfboat into the water was no easy feat. Twenty-six feet long, the wooden lifeboats weighed a thousand pounds and its carriage weighed another thousand pounds. Hauling both through sand required tremendous strength. Practice

also included deliberately capsizing the surfboat in the water, righting it and regaining a seat.

There were times when a surfboat was impractical and possibly dangerous, depending on the ship's location and the condition of the seas. In 1877, Major David A. Lyle of the U.S. Army developed the 160-pound, cast-bronze Lyle gun for the surfmen to use in rescue operations relatively close to shore. The small black-powder cannon shot a 17-pound projectile toward the top of the ship. Ideally, it would catch and hook in the rigging or the ship's crew could grab it and affix the line.

After the line was attached, the surfmen transferred the heavier whip line, which connected the beach and the ship, to create a rope-and-pulley system. A placard attached to the line provided instructions to the ship's crew: "Make the tail of this block fast to the lower mast well up. If masts are gone, then to the best place you can find. Cast off shot line. See that the rope in the block runs free and show signal to shore." The information was written in both English and French, since the apparatus was used along the Great Lakes.

Once rigged, the surfmen could send over a breeches buoy to the ship. The device was aptly named; the victim stepped into a pair of canvas breeches sewn into a buoy that attached to the line that was anchored on the shore. The apparatus was useful up to five hundred yards.

Log accounts from Indian River Life-Saving Station describe the use of a breeches buoy, which has been published in Robert Trapani Jr.'s book *Journey Along the Sands*. According to an account on February 2, 1902, the American schooner *Anna Murray* became stranded at 5:50 a.m. about two and a half miles south of the Indian River Life-Saving Station in a strong northerly gale and snowstorm. A patrol did not discover the schooner until 9:30 a.m., when the storm had abated just enough for the surfmen to see. Ice and snowdrifts prevented the use of retrieving the station's equipment in a timely manner, so the crew called on the Fenwick Island Life-Saving Station to bring equipment from a halfway house.

"After a hard struggle, both crews were united south of the inlet near the top of the schooner, which was listed off shore, pounding and grinding heavily and in a most perilous position—the seas and spray flying over her, half-masthead high, and covering her with ice."

A shot fired from the Lyle gun landed in the rigging, but ice cut the line, which fell toward the sea. Before it was lost, a crew member caught the line and managed to receive and secure the whip line. The Indian River Life-Saving Station keeper, Washington Vickers, was hauled on board via

the breeches buoy to assess the damage. The crew of ten men then took turns using the buoy to reach land, making a total of twenty-five trips back and forth.

In addition to the breeches buoy, rescuers also used a "surf car," a small boat with a metal top that closed after two or three people crawled inside it. The surf car was also attached to a ship-to-shore line. As with the surfboat, using both devices required practice drills. The surfmen used a twenty-foot-high "wreck pole" on land as a stand-in for a ship's mast.

Each surfman was equipped with a Coston flair, created by Martha J. Coston. Widowed at age twenty-one, Coston used blueprints left by her inventor husband to create the red, white and green flares, which were used for ship-to-ship and ship-to-shore signaling. The device was useful. At 12:20 a.m. on September 21, 1877, surfman William Carson was patrolling the beach when he spotted a vessel's light offshore. It was a steamer, and it was headed straight for the breakers. He immediately burned his Coston light and flashed it at the steamer as a warning. The steamer answered with its own light and changed course.

At four-hour intervals, two surfmen set out in separate directions toward the stations on either side of them. Each walked two and a half miles to meet their counterpart from the other station and exchange patrol reports. As proof that they completed their task, the surfmen made an impression on a copper dial, located in a box accessible only by key.

The patrols were arduous in bad weather. Then again, bad weather was the norm for these men's activities. An 1881 report from the U.S. Life-Saving Service summed it up:

> *Winter and rough weather are the companions of the journey—all natural vicissitudes, all hardships, all exposures known between the autumnal and vernal equinoxes; bitter cold, rain in torrents, cutting sleet, blinding flights of sand and spray, tides that flood the very dunes behind the beaches, the terrible snowstorm, the suffocating blasts of hurricane...No duty could make higher demands upon the moral nature of patrolmen [who venture] into the awful solitude of the winter beaches, perhaps on nights when the tempest makes the heavens and earth tremble.*

Despite all their equipment, sometimes there was nothing the surfmen could do but watch the destruction. On October 22, 1891, the twenty-eight-ton fishing schooner *Red Wing* ran aground south of Indian River Inlet. The

south foot patrolman of the Indian River Life-Saving Station spotted the distressed ship's flare, and the crew ran to its aid. Before they could reach the ship, it had broken apart, and the bodies of the six crewmembers washed up the next morning on the shore.

Shipwrecks continued even after the advent of steamships, as schooners were still very much in use. On April 21, 1911, the 148-foot schooner *O.D. Witherall*, was carrying ballast from New York to Philadelphia, south of Bethany Beach. The ship, built in 1874, was a novel curiosity for the residents, who climbed all over it, and the photographers, who captured it on film. Even experienced area sailors and pilots fell victim to the hazardous waters. The pilot schooner *W.W. Kerr* wrecked in about 1890 right in front of the Lewes Life-Saving Station. The schooner *Alaska*, part of the enormous fleet that fished for menhaden during that fishery's heyday in Lewes, foundered on Lewes Beach in 1903 and was declared a total loss.

Steamships may not have prevented shipwrecks, but they did help lower the incidence. In 1915, the federal government merged the U.S. Life-Saving Service with the U.S. Revenue Cutter Service to form the U.S. Coast Guard. Better navigational aids and weather prognostication also decreased shipwrecks to the extent that the same number of stations was no longer necessary. The old Lewes Life-Saving Station was relocated to Cape Henlopen, where it hosted a men's club, and then the Fort Miles Surf Club, an officers' club. It later moved to Rehoboth Beach, where it now serves as the Rehoboth Beach VFW. The old boathouse was donated to the Lewes Historical Society in 1979 when the Pilots' Association for the Bay & River Delaware took over the Coast Guard building from the University of Delaware. The white boathouse now shares canal-front space with *Overfalls*.

The Indian River Life-Saving Station, now a museum, has been restored to its 1905 appearance. The building was originally located four hundred feet closer to the shore, but a sand dune began to form around it almost as soon as it was finished. Moved to its present location in 1877, it is listed on the National Register of Historic Places.

THE ELEMENTS OF A DISASTER

THE GREAT WHITE HURRICANE

Earth, water, fire, air—the four ancient elements can each play a part in causing a shipwreck. Delaware witnessed four extraordinary examples of these elements' impact with the Blizzard of 1888, the Storm of 1889 and the burning of the *Mohawk* and its sister ship, the *Lenape*, which both caught fire in 1925. (The *Mohawk*, which went down in a winter storm, experienced the power of all four elements at once.) As far as doing the most damage and causing the most terror, the Blizzard of 1888, also called the Great White Hurricane, takes the prize.

The morning of March 11, 1888, was a mild one. During the entire first week of March, there had been a welcome hint of spring in the air. No one expected the union of two powerful storms, whose convergence would prove deadly.

Originating over the Rocky Mountains, the first system had barreled eastward like some ravenous monster growing stronger and more ferocious as it charged toward the coast. Another storm, in the Carolinas, was marching northward, picking up speed as it moved toward the Delaware Breakwater.

That evening between thirty-five and forty barks, brigantines, tugs, schooners and steamships were anchored at the breakwater, tucked in like sleepy children. The rain that had started falling earlier picked up, and there was a chilly breeze from the southwest. There seemed no cause for alarm. Captain Charles Townsend of the 178-ton tug *Tamesi*, anchored at the breakwater, later confided, "We did not have the faintest idea that we were going to have a storm until it came right down on us."

Nevertheless, John Clampitt, captain of the Lewes Life-Saving Station, and Theodore Salmons, captain of the Cape Henlopen Life-Saving Station, kept an experienced eye on the weather gauges. Perhaps it was the keen sixth sense they had developed over the years that made them feel the danger in their bones. Or perhaps they possessed an innate barometer.

The storm descended with incredible swiftness. The wind blew from the north-northwest and then took a drastic turn, shifting from the southwest. The rain turned to snow and sleet, and powerful waves rushed toward shore, pushing the anchored boats around like flotsam.

As the temperature dropped, ice started to coat the rigging, sails and decks of the ships around the breakwater. The winds turned the ice and snow into projectiles. One seasoned sea captain later said, "It was the worst storm I have seen in thirty-five years. You couldn't look to windward; it would cut your eyes out."

With the oily seas sliding over the decks, and the battering wind and waves thrashing the ships against the pier, it was imperative that those anchored at the breakwater move away from one another to avoid collisions. Yet many

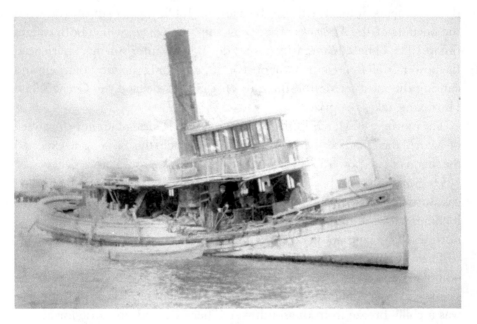

The tug *Lizzie Crawford* was anchored at the Delaware Breakwater when the Blizzard of 1888 descended on the area, smashing ships against each other and causing widespread damage. *Courtesy of the Lewes Historical Society.*

were trapped. The 102-ton *George G. Simpson*, a steamer from Philadelphia, was sandwiched between the *Lizzie Crawford*, a steam tug, and the steamboat pier. The *Lizzie Crawford* in turn was blocked by the *Tamesi*, which had no steam in the boilers.

Conditions continued to worsen. According to the U.S. Life-Saving Service's annual report for 1888:

> *The whole fleet* [of ships in the Delaware Breakwater] *was suddenly thrown into the wildest commotion; chains were sundered, masts shattered, and collision wreck, and indescribable chaos followed...The waters were stirred into turbulence and uproar, which with raging storm-wind, driving and roaring through the pitch-blackness of the night were enough to appall even the stoutest heart. The terrified crews on board the vessels barely had enough time to escape from their berths and scramble on deck or into the rigging for safety.*

Aboard the *George G. Simpson*, mate George Robinson jumped as though he had been shot when the donkey engine that operated the pump ruptured, sending a shrill whistle into the bitingly cold air. In his haste to repair it, he tripped over lumber that had fallen to the deck and landed in the water. By luck, he was able to grasp a rope and pull himself back on board, where he shut off the steam to the engine to kill its scream.

As the *Tamesi* finally started to move, it collided with the *Simpson*, whose bow ripped a gash in the *Tamesi*'s side. The terrified crew instinctively leapt to the pier and its pilings. They watched with dread as the ship moved forward on its engine's momentum and finally sank about a half-mile away. They reached out to snag crew from the *George G. Simpson*, which was pitching and careening like an amusement park ride. With only four people aboard, including Robinson, the ship bucked the waves like a mechanical bull. The donkey pump was useless, and the vessel took on water.

A vicious wave crashed over the *Lizzie Crawford*, shoving the tug through the pier so ruthlessly that the collision ripped into the housing and decking, exposing the interior. The collision succeeded in cutting the pier in two pieces. The crews from the *Tamesi* and the *Simpson* were stranded on the far end. Pieces of the ice-crusted pier began breaking away, falling into the hungry surf like giant ice cubes.

Shivering on the pier's end and encrusted with ice, the men watched the activity before them from a terrifying vantage point. A three-masted schooner

zipped by the breakwater, headed for shore, with the crew dangling in the rigging, one already dead. The wind hurled a glittering Norwegian bark, blanketed in ice, toward the beach. A two-masted schooner also barrelled toward shore. The ship's crew, lashed to the main mast to keep from falling overboard, were open-mouthed with terror. Their screams, however, were swallowed by the howling wind. Perhaps it was the cold. Perhaps it was

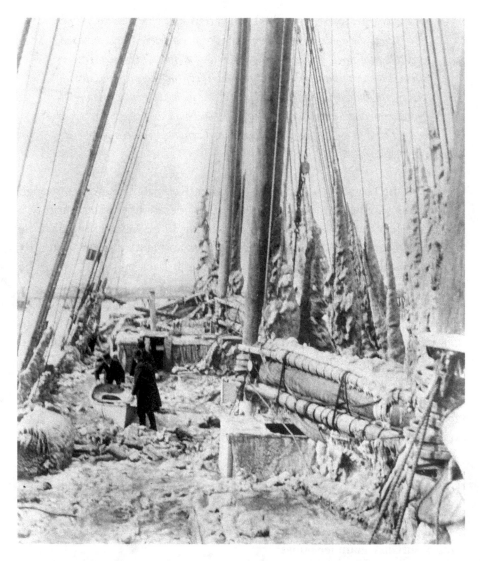

The Blizzard of 1888 came on fast, dumping snow, ice, sleet and rain on the unsuspecting ships anchored at the Delaware Breakwater and coating the ships—and the crews lashed to the masts—with ice. *Courtesy of the Delaware Public Archives.*

hunger or the shock. Whatever the reason, the men on the pier went for twenty-three hours without saying a word, Townsend recalled.

Aboard the *George G. Simpson*, the four remaining people, including Captain Hardy Holt and his wife, attempted to steer the ship toward the breakwater, where they had spotted another vessel, a wrecking tug, *Protector*. It would prove an apt name. When *Simpson*'s anchor failed to catch, crew aboard the *Protector* threw the sinking *Simpson* a line. It took two attempts before the line held, and the waves, Holt later recalled, were "running as high as a three-story house." Everyone but Captain Holt jumped safely to the *Protector*'s deck. Holt whacked his head on a stanchion, which knocked him unconscious for a half hour. By the time he regained consciousness, the *George G. Simpson* had sank.

For the lifesaving crews, the night passed in frustrating anxiety. There was nothing they could do while the storm raged with such intensity in the black night. Before dawn, Clampitt's men at the Lewes Life-Saving Station ventured out onto the beach. But the ninety-mile-per-hour winds spewed cutting snow, sand and freezing rain into their face so viciously that they crawled back to the stationhouse on their hands and knees. In the early morning light, during a brief lull, they tried again, counting no less than twenty schooners and two steamers sunk, sinking or aground. All around the breakwater, ship anchors pulled free and masts snapped.

The surfmen targeted the three-masted, 169-ton *Allie H. Belden*, a schooner-rigged vessel that had struck ground several hundred yards from shore. The ship, which had come down from Boothbay, Maine, carried a cargo that included, ironically, ice. The crew had tied themselves high in the rigging to wait out the storm. No sooner had the surfmen started rescue attempts then the capricious storm regained its fury. The first fire from the Lyle gun zipped the line right within reach of the captain, but his hands were so frozen he couldn't hold on to it. On the second attempt, the line shot over the ship, beyond the sailors' reach. One line froze stiff and parted when shot, rendering it useless.

There was nothing to do but prepare the surfboat. Clampitt ordered the men to cast a line to the crew aboard the pilot boat *Ebe W. Tunnell* to help guide the boat through the punishing waves breaking on the beach. The surf kept beating them back. Volunteers then helped the surfmen wade the boat across the breaking surf. The men were so exhausted that they were forced to rest before going forward. Anchor, rest and row. Anchor, rest and row. The rescuers finally made it to the *Belden* at 2:00 p.m., nine hours after the

rescue attempt began. They transported four frostbitten men who were close to dying from exposure. Two had not survived after falling from the rigging during the night. The lifesavers took the frostbitten men to the stationhouse, where Dr. David Hall, a Lewes physician, awaited them.

Surfmen from the Cape Henlopen Station borrowed the Lyle gun from the Lewes crew to come to the assistance of the New York schooner *William G. Bartlett*. En route, they paused to rescue the seven-man crew of the pilot boat *Enoch Turley* using the breeches buoy. Unfortunately, the rescue used up the last shot line for the Lyle gun; they were left with only the heavy lifesaving boat from the nearby Marine Hospital to rescue the men aboard the *William G. Bartlett*. While lugging the boat on its carriage down to the surf, they found three of the *Bartlett*'s crew in the frigid water and pulled them to shore. Again the surfmen made for the *Bartlett*, which was about eight hundred yards from shore. The rescuers' uniforms were stiff with ice, and their faces were numb from the cold snow and sleet. Aboard the ship, one man had died after spending eighteen hours lashed to the rigging. Two, who were nearly dead, were taken ashore.

Dag Joseph, then the keeper of the Cape Henlopen Lighthouse, watched the *C.B. Hazeltine*, laden with 1,190 tons of coal and a five-member crew, break up in the surf. "No human power could have saved her, even had aid been possible, and in a short time she was among the terrible breakers that were leaping high into the air over what was probably the most fatal and dangers shoals on the middle Atlantic coast," he said. Rescuers finally made it to the men on the end of the steamship pier. They were so stiff and frozen that the rescuers had to pry them from their huddle and place them in the rescue boats like ice-covered cargo.

The storm's center hovered like a frosty demon over the coast for three full days. By March 15, the aftereffects made the beach and bay look like a water-logged disaster area. Masts poked from waters strewn with debris. Ships listed onto their sides, and some were torn apart, splintered boards sticking out of their sides like stacks of giant toothpicks. Many looked as though they had suffered brutal amputations and eviscerations. Decks were covered in jagged ice, and icicles dangled from the rigging.

In all, the Lewes and Cape Henlopen lifesaving crews rescued 178 seamen, and damages along the Atlantic coast ran into the millions. The snow paralyzed transportation in New York, prompting officials to consider a subway system.

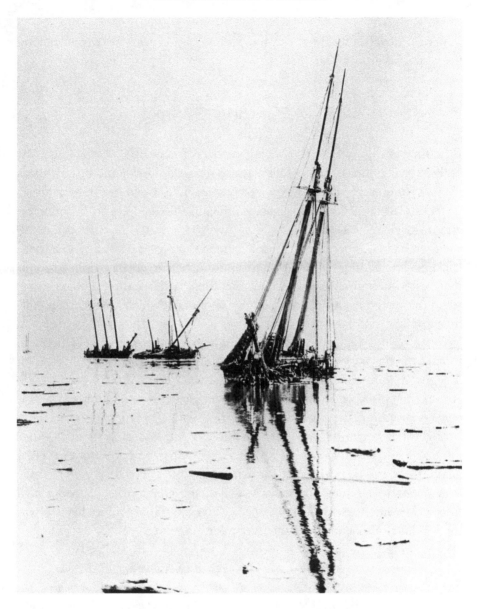

In the aftermath of the Blizzard of 1888, the corpses of sunken ships poked out of the ice-strewn water. *Courtesy of the Delaware Public Archives.*

It was thought that the storm was a once-in-a-century occurrence along the coast. Just over a year later, the weather would prove them wrong.

THE FURIOUS STORM

Brooding clouds started to congregate over Delaware's coastal towns as early as September 8, 1889. This was not unusual. Lewes and its neighbors were accustomed to the threat of nor'easters. Life went on. On September 9, the storm landed over Delaware, knocking down trees in Wilmington and damaging the Dover peach crop. By 4:00 a.m. the next morning, the weather had considerably worsened, and reports of beached vessels were trickling into the Lewes Life-Saving Station. Sea levels had risen to levels that residents had not seen in their lifetimes. At least three feet of water stood between the edge of town and Lewes Beach, which are at least a half-mile apart.

Close to the cape, the town of Hugheyville was completely flooded, forcing the evacuation of more than two hundred people to higher ground. Telegraph communication with the breakwater went down by 9:00 a.m. Around the breakwater, there were between sixty and one hundred vessels packed together. The high tides combined with the churning waves and strong winds began to batter the anchored ships, knocking them together just as they had in 1888. Lessons learned then seemed forgotten. Then again, there was no other place for the ships to seek safe harbor.

A *Philadelphia Inquirer* journalist watched the chaos from his room at a Lewes boardinghouse, which he called the Verdin House (more likely it was the Virdin House, named for the river pilot's family):

> *It is impossible to give the extent of damage done to shipping at this point by the storm, which has raged for the past forty-eight hours and is now unabated. The wind is blowing seventy miles an hour at this time (9 p.m.), and there are seventeen sails ashore, with a full score more fast drawing into the breakers...The oldest sailors here say there had never been a storm at this point to compare with this. The crews of sixteen of the wrecked vessels are now at the Verdin House, being cared for by the proprietors... As I write a terrible sight is being witnessed by the dozen brave men on the shore composing the life-saving crew of Lewes Station...A three-masted schooner is ashore just outside the inner bar and is fast going to pieces, with*

her crew of ten men clinging to the rigging...The lines which the brave life-saving crew have shot over her are tangled in such a manner as to make it impossible to use the [life] car. It is a terrible sight to witness, and yet no human power can save them. In the morning their bodies will possibly be washed ashore and receive burial in the sand along the river.

The property damage began to escalate. The storm battered the Marine Hospital and the Maritime Exchange Station on the breakwater. The men at the station had watched in panic as the waves lunged at the breakwater, and the sound of the foghorn was drowned out by the punishing wind. Fortunately, the tug *Arugus* came along to rescue them. Waves washed away the piers owned by Brown and Company and the Leuce Brothers. In Rehoboth Beach, the surf washed out Surf Avenue and slid onto the porch of the Bright Hotel. The Lewes Life-Saving Station, normally forty feet above high water, was flooded.

A September 12 story in the *New York Times* noted that the storm "was the most furious storm known to the oldest inhabitants. At least two score vessels are now beached...The beach from Rehoboth to Lewes is strewn with wrecks. It is thought at least fifty lives were lost. Men were seen clinging to the rigging of fast-seeking vessels, frantically yelling for help."

Vessels continued to stack up on the beach, including an unknown schooner in Rehoboth. In Lewes, schooners *Alena Covert, Henry M. Clarke, J.S. Becker, Byron M., Norena, Gertrude Summers* and four unknown schooners slammed against the sand.

Full of water, the Italian brig *Il Salvatore*, sailing from Philadelphia with a cargo of oil, went ashore near the iron pier, tearing off its entire stern. Surfmen attempted to reach the ship with a surfboat, but it was too heavy to drag near the scene. Clampitt ordered a team of oxen to take the surfboat to the water's edge. But, as daylight came, Clampitt saw that the ship was already breaking into pieces. He ordered the crew to jump onto the pier, which they did, suffering only minor injuries.

Surfmen from the Cape Henlopen Life-Saving Station joined the Lewes crew just in time to see a two-masted schooner, the *Charles P. Stickney*, snap its chains and careen toward shore. The ship was just seventy-five yards from the beach, and the first shot from the Lyle gun was a success. By breeches buoy, the six-member crew made it safely to land. Shortly thereafter, the schooner broke up.

Reaching the *Gertrude Summers*, a fishing schooner, was proving problematic. A wreck lay between the vessel and the shore. The surfmen cleverly fired

the Lyle gun from the second story of a nearby boathouse to establish a connection with the schooner. While the waves crashed over both the schooner and the boathouse, the surfmen managed to save the fourteen-member crew. Later, the *Summers* captain was reported to quip that he had survived previous shipwrecks and was happy to say that "he had fooled Davy Jones once again." (Davy Jones is an idiom for the bottom of the sea or rather the devil who ruled the sea.)

Meanwhile, the scene near the Fourteen Foot Bank Lighthouse near Bowers Beach, north of Lewes, was out of Dante's *Inferno*. Two coal-laden schooners, the *Walter F. Parker* from Philadelphia and the *Kate E. Morse* were in their death throes. The *Kate E. Morse*, owned by Morse and Co., of Bath, Maine, had loaded up its cargo in Philadelphia and was en route to Boston. By the time the *Morse* reached the breakwater, the storm was in force. Despite one anchor embedded in ninety feet of water, the cables parted and the helpless ship was cut loose in the water. It landed onto the Hawks Nest Shoal and rolled onto its side. The crew clambered into the rigging as the waves engulfed the deck.

The *Parker* landed within thirty yards of the *Morse*. As the crew aboard the *Morse* watched, a large wave swamped the *Parker*, taking the seven men under. Only six resurfaced, still clinging to the rigging. As the day wore on, the *Parker* began to break up. The *Parker*'s men had little choice. One by one, they jumped into the sea before the ship was gone.

After forty hours of agony, the men from the *Morse* were ready to give up. Then they sighted the tug *A.L. Luckenbach*, which had left Philadelphia to offer assistance. While attempting the rescue, the tug hit a shoal and broke the windlass. The anchor could not be retrieved until nightfall. Staying beside the *Morse* through the night, the tug in the morning tried again. The *Morse* crew caught the lines thrown to them and jumped into the water. The *Luckenbach* crew then hauled them aboard.

The schooner *J. & L. Bryan*, like many ships, lost its anchor in the storm and went rocketing down toward the Delaware Bay. After the mast fell across the ship, crushing the boat, and the steering apparatus broke, the men lashed themselves to floating debris. With the rope cutting their flesh and the rain and waves threatening to drown them, two men finally drifted ashore two miles from Lewes. Though bruised and battered, they walked into town.

By September 12, at least forty-three vessels were lost or stranded along the Delaware coast. Many were uninsured. The coal-laden schooner *William O. Snow*, from Philadelphia, was found abandoned and sinking several miles

up the bay. The crew was never heard from. The pilot boat *Ebe W. Tunnell*, which had survived the blizzard the year before, disappeared with all aboard.

In the aftermath, critics pointed fingers at the beleaguered breakwater, which had been deemed too small for service practically since it was built. "The place is now a trap for shipping," one newspaper seethed. "Vessels run in there to avoid a coming storm, and are wrecked at their anchors, while the crews drowned." As a result, Congress authorized the building of the Harbor of Refuge, which went into service in 1901.

Praise, however, rained down on the lifesaving service. General Superintendent S.I. Kimball in October issued a letter of commendation to Keepers Clampitt, Salmons and Truxton:

> *The gallant conduct shown by yourselves and by the crews under your command during the great storm of September 10 to 12 has been noted by this office…you combined your crews and gave efficient aid to no less than twenty-two vessels, taking off by boat thirty-nine persons and by line apparatus one hundred and fifty-five, a total of one hundred and ninety-four persons, not a life being lost from any vessel that came within the scope of your attention.*

FIRE AND ICE

It was New Year's Day 1925, but for the 287 people aboard the *Mohawk*, the New Year had a less-than-promising start. A fire raged in the afterhold, and a storm's forty-mile-per-hour winds pounded the ship with snow, sleet and ice.

The 4,623-ton liner, owned by Clyde Steamship Company in New York (more commonly known as the Clyde Line), had left its berth in New York on a bitterly cold day bound for Jacksonville, Florida. Built in 1908 by William Cramp & Sons in Philadelphia, the *Mohawk* carried 80 crewmembers, 207 passengers (some of whom were Florida resort hotel employees heading south for seasonal work) and a cargo that included sixty-eight shiny new automobiles.

Not long after leaving New York in the mid-afternoon, Amelia Bulkley smelled smoke in her stateroom. When she peered out into the corridor, she was met by dark, billowing clouds. She ran for help, but the crew was already aware of the problem. They had been battling a fire in the afterhold, which Chief Engineer Charles Rich had found about 7:00 p.m. when the ship was

about twenty-five miles off the coast of Atlantic City. Captain James Staples hoped that the crew could quickly handle the fire before the passengers were any wiser.

Fire was always a hazard on a steamship, as evidenced by an 1838 federal law implementing safety standard due to the frequent number of deaths from boiler explosions and fire. Despite laws in 1852 and 1871 that established and strengthened a federal maritime inspection service, steamboats still caught fire. Credit in part went to cigarette smoking, which was never a good thing around wooden decks, and flammable cargo such as cotton.

According to William Turner, an engine room oiler on the *Mohawk*, "Using sledgehammers we broke down the bulkheads and chopped up the deck to get at it, and all the time the ship was rolling and pitching. But the water supply was good and the lights stayed on."

Staples stayed on course, opting to head for the Delaware capes rather than return to New York. It was a smart move, said Captain A. Hayes, commander of the U.S. Coast Guard cutter *Kickapoo*. Turning into the gale would have been folly, and by the time the ship reached New York, it would have been "an inferno."

As it was, things did not look favorable for the ship. While smoke curled under the radio shack's door, Chief Radio Operator Thomas Schmidt and his assistant spent twelve hours posting the ship's current position. *Kickapoo* left its post in Cape May, and tugs *Mars* and *Kaleen* left the safety of the Delaware Breakwater to come to the *Mohawk*'s aid.

At about 11:45 p.m., the crew notified the passengers, who assembled the next morning in the dining hall. "There was very little excitement after the first announcement that we must put on the life-belts because the ship was on fire," passenger Helen Alder Kinney later told a *New York Times* reporter. "We were in our cabin just before midnight when we learned that the ship was on fire. We put on our life-belts and then went on deck. Only a few of the women became hysterical and we others did what we could to comfort them."

Most of the passengers were not dressed for the environment, but they were too scared to venture back to their cabins. Others had the wherewithal to put together a small bundle or satchel of possessions. While some passengers sat and talked, others sang or played ukuleles, banjos and guitars. One teenager helped make coffee. May Cullen, remembered both for her youth and red hair, entreated passengers in the main saloon to pray. "Let's get down on our knees and ask Almighty God to aid us," she said. Later, she told a reporter,

"After we had been reassured by the Captain that there was no immediate danger I don't think any of us were really afraid." When the ship started to list, things became more "uncomfortable," she added. To avoid the smoky rooms, many stayed on the deck, preferring the snow and sleet to the smell of the cars' rubber tires burning.

The liner lurched on the tumultuous seas, pitching forward and rolling to the sides. In the early hours of the morning, the *Mohawk* finally reached the Delaware Breakwater, but there was already a bevy of ships seeking shelter there. The seas were too rough to ensure the safe transport of one ship to another. Captain Staples headed to the lightship at the Brandywine Shoal for the passenger transfer. "Captain Staples and the crew did everything they could for us, but it was little enough they could do, with the ship standing on end every few minutes and the fire to be fought," passenger Evelyn Demrate of Brooklyn told a reporter.

About twelve miles from Lewes, the ship listed heavily toward its starboard side, knocking some passengers off their feet. By now, tongues of flame had come through the deck and were whipping skyward into the swirling sleet. In choppy water after dawn, the Coast Guard cutter *Kickapoo* and tugs *Kaleen* and *Mars* took turns taking on the *Mohawk*'s passengers via Jacob's ladders, rope ladders with inflexible rungs.

Most of the women were rescued first. Two, however, had returned to their cabins upon daylight to sleep, and rescuers had to carry them to safety as they clutched their discarded apparel. "We had hardly pulled away when the flames shot up from the hold and licked around the very place were we had been only a few minutes before," recalled another passenger, Sadie Thompson.

The heaving seas made navigating the ladder a challenge. J.J. McGrath of New York fractured his arm during the transfer. When the tugs heaved on the particularly rolling waves, the sailors were forced to pull up the ladder to wait out the surge. Impatient and terrified, some opted to jump to the waiting ship. A midshipman fell so hard that he was knocked unconscious and remained so even after the survivors landed in Lewes.

As the rescue ships pulled away, two figures were seen on the *Mohawk*'s deck, waving their arms. It was Louis Haydock and James Simpson, members of a vaudeville team who had slept through all the smoke and excitement. (Some accounts maintain that the men had returned for their bags, but a fallen beam had blocked their way out of a saloon door.) They leapt into the icy water and thrashed their way to the *Mars*, where people pulled them aboard.

The passengers landed at the Fish Oil Company pier and were taken to the Hotel Rodney in Lewes, where they were fed for the first time in eighteen hours. Reportedly, everyone had been rescued except for two cats and a dog.

As the fire consumed the *Mohawk*, flickering through its decks and portholes, trains whisked the passengers up to Wilmington, where they boarded other trains either to New York or to Jacksonville. Most had no bags or satchels, and more than a few were disgruntled that they could not rest in Wilmington before having to set out yet again.

On January 4, the weather cleared enough that search parties could explore the area where the *Mohawk* last drifted aground on a shoal in about ten feet of water. The ship was still on fire. By the next day, the liner was a skeleton of itself, its mainmast hanging. The remains were later destroyed and allowed to sink to the bottom. Because the area is so shallow, its metal wreckage could damage small crafts. A buoy not only serves as a warning but also as a tombstone.

SMOKE ACROSS THE WATER

At 4:00 a.m. on November 18, 1925, many of Lewes's 2,200 residents awoke to the prolonged blast of the fire alarm, followed by three short, shrill whistles. Those who made it down to the shoreline saw a sight that was both difficult to comprehend and impossible to forget: the 399-foot SS *Lenape*, bound from New York to Jacksonville, Florida, was engulfed in flames that shot as high as 100 feet into the air. Smoke billowed across the breakwater, where the listing ship had taken refuge.

The residents of the maritime town were accustomed to devastating storms that hurled ships aground like bath toys. This, however, was something totally new. And for the ship's passengers, it had been totally unexpected. The *Lenape* left New York at 2:23 p.m. on November 17 headed to Jacksonville with a stop in Charleston. The steel-hulled liner was well seasoned. It had been built in 1912 by the Newport News and Dry Dock Company in Newport News, Virginia, and delivered on January 18, 1913, to the Clyde Steamship Company in New York.

As the first and smallest of the seven ships that the Newport News shipbuilding company would build for the Clyde Line between 1912 and 1926, the single-stack *Lenape* could transport 3,889 tons, including 350 passengers and 90 crewmembers, as well as cargo. When the *Lenape* left Pier

The SS *Lenape* in 1925 caught fire while en route to Jacksonville, Florida, forcing it to seek help in Lewes Harbor. *Courtesy of The Mariners' Museum, Newport News, Virginia.*

36, it held 318 passengers, 100 crewmembers, 1,500 tons of general cargo and forty-nine automobiles.

The ship was under the command of Captain Charles W. Devereux, who went to work for the Clyde Line in 1893 while in his mid-twenties. By 1904, he had made captain. After the United States entered World War I on April 6, 1917, the army commandeered the *Lenape* to use for troop transports, which was not unusual for the time. Devereux volunteered for convoy duty and remained in charge. He continued in that role when the navy in 1918 took control. Rechristened the USS *Lenape*, the vessel made three round-trip voyages to France, carrying service personnel to the European front. (Devereux also commanded the former civilian freighter USS *West Haven*.) In October, the *Lenape* bounced back to the army. At the war's end, the *Lenape* returned to civilian life, and Devereux was back at the helm.

No doubt he was feeling confident on November 17, 1925, which was a clear, cold and sunny day. The moderate breeze tossed up some whitecaps, but

that was no concern for the 5,179-gross-ton *Lenape*, whose 3,500-horsepower engine could cut through waves at a top speed of fifteen knots.

Among the passengers were Julia Davies Arnold and her three children: Willard B., born in 1915 and named for his father; Gordon, born in 1917; and baby George, born in August 1925. The Vermont family was en route to Florida to reunite with Julia's husband, Willard C., a minister hoping to find a job and a more hospitable climate for his asthma.

In the book *Ablaze in Lewes Harbor*, author Bob Kotowski recounts the family's adventure on the ship. Willard and Gordon were excited, particularly when the *Lenape* glided past the Statue of Liberty. They had never been on a ship so large. At that time, three of the Clyde Line ships, including the *Lenape*, had all first-class accommodations, and in cabin #74, the children tried their lifejackets on for size.

By 10:30 p.m., the only cause for alarm had come during dinner, when a jittery waiter dropped a tray of dishes on the floor. "We wondered if the crew knew something that they were not telling the passengers," Julia's son Willard later wrote in a memoir. At 10:55 p.m., Third Engineer Joseph Pena noticed smoke snaking through the bulkhead vent separating the cargo hold from the engine room. Pena notified the bridge, and the crew turned on the saltwater pumps, charged the ship's two-and-a-half-inch rubber fire hoses and grabbed fire extinguishers.

By 11:15 p.m., as the ship neared the lightship at the Five Fathom Bank, about eighteen miles southeast of Cape May, New Jersey, the first distress call went out. It was heard by ships and land stations from Key West to New England, but most were too far away to do any good.

The crew began rousing passengers. According to Julia's memoirs, a cabin steward ran past the family's stateroom yelling "Fire! Put on your lifebelts and come to the music room." She made the older boys pull on overcoats over their pajamas and don shoes before helping them with their lifejackets. In the music room, people arrived in all manner of dress, including long underwear. A woman with a baby was so overcome with fear that she fainted.

The fire was spreading below deck. Devereux decided to make a run for the Delaware Breakwater in Lewes Harbor. Alerts from the ship increased: "Afire. Smoking badly." Peering through the billowing smoke, the passengers were brought to the upper deck. The Arnold family sat on deck chairs, determined not to show fear. Many passengers were equally stoic albeit nervous. Willard later wrote of one man who chain-smoked, singing "Oh, It Ain't Gonna Rain No More," a song also sung

by passengers aboard the *Mohawk*, a Clyde liner that had burned near the breakwater just that January.

Meanwhile, David W. Burbage, the Clyde Line passenger agent in Lewes, learned of the fire via the Maritime Radio Station in Tuckertown, New Jersey. He alerted the Coast Guard, and word spread. Robert C. Chambers, a pilot since 1871, notified other pilots and apprentice pilots before heading to *Overfalls*, the lightship. On that night, Chambers and Lewes native Charles S. Morris, licensed in 1882, were aboard the *Philadelphia #2*, a 148-foot-long steam pilot boat built in 1889 by Neafie & Levy Ship and Engine Building Company of Philadelphia at a cost of $70,000. The ship replaced the *Philadelphia*, which the navy had bought and converted to a gunboat during the Spanish-American War.

Like the other local pilot boats, the *Philadelphia #2* paroled the shipping channel at the Delaware Bay's entrance. Ships coming up the river stopped so a pilot from the pilot boat could board and navigate the ship through unfamiliar and often treacherous waters.

At 2:00 a.m., the *Lenape* approached *Overfalls*. Morris later told a reporter that no searchlights or binoculars were needed; the ship was a cloud of smoke. "For God's sake, save us," passengers called to the pilot boat as it passed right by the ship. The *Philadelphia #2* was not ignoring them. It had

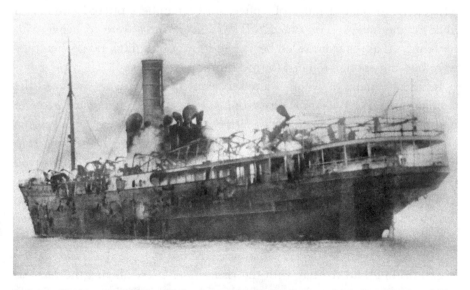

In Lewes Harbor, the 399-foot SS *Lenape* was engulfed in flames, which shot as high as 100 feet into the air. *Courtesy of The Mariners' Museum, Newport News, Virginia.*

already launched skiffs, including one occupied by Morris. He boarded the *Lenape* and guided the ship toward the breakwater, where he ran it aground to avoid the wind, which would fan the flames.

Passengers and crew began abandoning the ship via lifeboats, which the skiffs guided to the pilot boat. The *Kickapoo* joined the effort. At 3:00 a.m., the fire roared through the deck at the ship's stern. As the hungry flames began consuming the ship, chaos ensued. Some of the remaining passengers and crew jumped into the water or dangled on ropes alongside the sides of the ship. Robert Leverton, sixty, of Willimansett, Massachusetts, grabbed rope and leapt from the boat. The force of his swing hurled him against the hull and he plummeted twenty feet into the water. A fisherman found his body an hour later.

Julia, separated from her two older sons, was put into a lifeboat that was ineptly lowered, jerked first by one side then by the other. Passengers had to cut the rope with a penknife and push against the hull's hot sides to get away. Gordon and Willard wound up on a lifeboat with some crewmembers.

The tide and the wind made it challenging for the lifeboats to move away from the ship, and the rescue ships came to the aid of many lifeboats that appeared as though they were ready to capsize. Residents boarded their own private boats to offer assistance. Julia and her sons were reunited on the *Philadelphia #2*, which was jammed with ten times its normal passenger load. The survivors shared mugs of coffee, and Chambers offered condensed milk for the babies. The *Philadelphia #2* and *Kickapoo* were so heavy with passengers that the overloaded boats had to wait until high tide, when they were buoyant enough to head toward shore.

Residents, many of whom waited to assist the passengers, watched the conflagration. Dr. William P. Orr's son, Robert, then age ten, later wrote in his book *A Small-Town Boyhood in the First State* that the ship was "an awesome experience to watch from our upstairs window at night—this blazing ship moving in the Bay." His father was among the medical professionals who waited on the dock to treat passengers, whose injuries included broken ankles, smoke inhalation, exposure and exhaustion. Residents donated clothing and food to passengers, who were taken to churches and private homes. Relief trains were en route to take passengers to New York or Jacksonville.

Morris, Devereux and a crewman were the last to leave the *Lenape*, which began drifting into the bay with the rising tide. Crew aboard the *Kickapoo* threw a line on the liner's stern chock and towed it back to shore, finally pulling it aground off Broadkill Beach, where it remained until January 16,

1926. There was talk of purchasing the *Lenape* and using it as a breakwater to help stem the erosion near the Cape Henlopen Lighthouse. But the Union Shipbuilding Company purchased the liner, which was towed to Baltimore for scrap. The lighthouse would tumble into the sea in April 1926.

Only one person, Leverton, died in the disaster, whose cause remains unknown. Speculation regarding arson was dismissed. Indeed, the Steamship Inspection Service concluded that there were no violations nor was there evidence of misconduct, and the *Lenape* drifted off away into history.

CLOSE ENCOUNTERS: COLLISIONS AT SEA

THE *CHAMPION* AND THE *LADY OCTAVIA*

Today, the Wilmington Riverfront is undergoing a renaissance, with new apartments, condos, restaurants and businesses popping up along the curving Christina River where the Swedes first created a settlement in the seventeenth century. But the towering cranes dangling over the attractions are tangible reminders that this area was once a vibrant shipbuilding mecca.

The industry here was dominated by Harlan and Hollingsworth, which was known for its steamships. One of the company's creations, the *Champion*, was a side-wheeler built in 1859 and owned by the New York and Charleston Steamship Company. The steam packet could accommodate 738 passengers and crew. But when the ship left its pier in New York at 5:00 p.m. on November 8, 1879, it carried 39 crew members, 16 passengers and light cargo, consisting of such items as butter, cheese, lard, hardware, saddlery, bacon, potatoes and sugar. The load was light because the ship had been called early to Charleston to pick up a cargo that was so heavy that two other ships could not handle it all.

Near 3:00 a.m., Captain R.W. Lockwood went off duty. The night was clear, the seas were smooth and the stars were shining. The *Champion* was steaming along at more than ten knots per hour, about thirty miles from Cape Henlopen and fifteen miles from the lightship on the Five Fathom Bank. From his room, which adjoined the pilot house, Lockwood heard the cry "Sail ahead!" When he got to the deck, he saw an approaching ship no more than one hundred yards away.

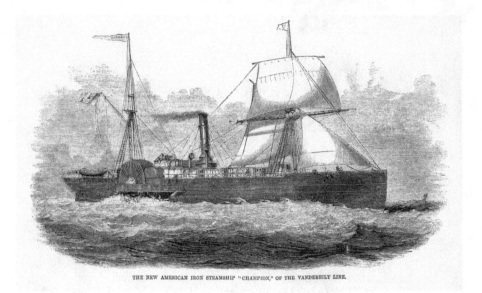

THE NEW AMERICAN IRON STEAMSHIP "CHAMPION," OF THE VANDERBILT LINE.

Built in Wilmington, Delaware, the *Champion*, a side-wheeler, collided with the *Lady Octavia* and sank in five minutes. Only twenty-four people on board survived. *Courtesy of The Mariners' Museum, Newport News, Virginia.*

Unbeknownst to Lockwood, it was the *Lady Octavia*, a British bark, which was moving between three and four knots per hour. Lockwood rang the bell, signaling the *Champion* to reverse, but it was too late. The ships slammed into each other. According to officers aboard the *Champion*, the *Lady Octavia* struck the *Champion* on the starboard side, locking the two vessels together for a time. The ships were so entangled that two of the *Champion*'s crew jumped onto the *Octavia*. The *Champion* broke free, perhaps owing to the fact that Lockwood had previously signaled reversal and the wheels were still in motion.

The *Champion* immediately began to sink. Even passengers who were awake had little time to put on life preservers. Survivor Charles E. Garner would have gone back to sleep except for all the commotion he heard on deck. He could not find his shoes, but he donned pants, a vest and an overcoat and ventured out to see women hurriedly putting on clothes. The scene on deck "was a horrible one," Garner said. "I saw in a minute that the only chance was to get a hold of something that would float and jump overboard before the ship went down."

Passengers rushed to the lifeboats, begging the crew to cut them free. The crew, however, were panicked, and in a *New York Times* article, they were later accused of taking the every-man-for-himself approach. No one appeared to be in command, survivor Joseph Mitchell later maintained. "I heard no orders and saw no attempt to help others." In the end, there was no time to put the five lifeboats and the life raft into the water, although one lifeboat did pop to the surface after the ship's sinking.

Richard Owings, age nineteen, was asleep in the forecastle when the collision occurred. A piece of ship timber pinned one of the men to his bunk. "When the vessels parted, I made a big leap through the big hole which was left in the *Champion*'s starboard bow, and somehow managed to scramble up on the *Octavia*'s deck by the martingale back ropes," Owings later told a reporter. His friend screamed for help but was too weak to grasp the rope that Owings tossed to him. A fireman rushed in, pulling the timber away, but when the water rushed into the forecastle, the man deserted the victim. "I'll have to leave you and save myself. Good-bye," the fireman said. The water, fortunately, pushed away the remaining timbers and set the friend free.

The ship was sinking so fast that people struggled to keep from slipping down steep inclines, grasping at the slanted deck with their fingernails as they slid toward the maelstrom. Indeed, the *Champion* went down in just five minutes, leaving only its topmast marking its spot. Everyone on deck, including the captain, was sucked down into the ship's death spiral. (Lockwood resurfaced and was later rescued.) "I heard a few cries and then there was a great rushing of water that seemed like a deep river running straight down to the bottom of the sea, and I was engulfed with all the rest, and went down I can't say how far enough, at any rate…when I came to the surface again, I was very nearly gone," said Garner, who credited the air in the top hat that he had jammed on his head before the sinking for his buoyancy.

A wave pushed passenger Mitchell onto a window sash. Although he cut his knees and arms on the glass, he clung desperately to the sash, even when a man staying afloat in a bobbing chair fought him for it and a man who had been floating in a tub joined in.

The *Lady Octavia* unfurled its sails and lowered a lifeboat, rescuing the hapless passengers and crew, who were thrashing among floating furniture and boxes that threatened to clobber them. The search continued until daylight. After making a final sweep through a spyglass, the *Octavia*'s boatswain reported no other survivors, and Captain Kames Johnson gave the order to take off. The boatswain, however, failed to see Miller, Garner and four others.

The leaking *Lady Octavia* limped forward toward Philadelphia with the *Champion*'s brass hawse-pipe embedded in its figurehead. There was a six-foot gash above and one below the water, and there was an eight-foot crack on its starboard bow. Outside Lewes, the *Octavia* signaled for assistance, and a tug towed the ship to Philadelphia. Back at the wreck site, the bark *Petit Codiac*, sailing from the Delaware Breakwater to New York, encountered the six men in the water, including Mitchell and Garner, who were now hanging on to a skylight, and rescued them. Only twenty-four people aboard the *Champion* survived the disaster. Twelve of the sixteen passengers perished.

Once in New York, Lockwood reported the calamity to his company. At that point, both captains blamed the other for the collision. Captain Johnson maintained that the *Champion* had no lookout, as he had heard that the person who should have been handling that task was loosening a sail under orders from R.H. Leonard, the first officer. He also accused the *Champion* of suddenly changing its course.

In the end, the local board of steam vessel inspectors put the blame on the lack of a lookout on the *Champion*. If Leonard had survived the collision, he would have suffered serious consequences. Credit was given to the *Lady Octavia* for its speedy rescue efforts.

THE *CLEOPATRA* AND THE *CRYSTAL WAVE*

It was early in the morning on October 29, 1889, and the 184-foot *Cleopatra*, a wooden, schooner-rigged steamer, and the 588-ton *Crystal Wave*, a sidewheeler, were traveling on a collision course.

The 1,045-ton *Cleopatra*, built in 1865 in Fairhaven, Connecticut, had a long history of travel with the International Steamship Company in New York, for which it had run a route from Boston to Nova Scotia. The Old Dominion Company had recently purchased the ship as an extra vessel. Under Captain Ira Dole's command, the ship had left West Point, Virginia, for New York with no passengers and nine hundred bales of cotton.

Built in 1875 in Greenpoint in Brooklyn, the *Crystal Wave* had been owned by the Bridgeport Steamship Company, and for the two previous seasons, it ran excursions out of Rockaway, New York. But it, too, had been recently purchased. With Captain Samuel Martin at the helm, the *Cleopatra* was on its way to Washington, D.C., the home of its new owner, Captain E.S. Randall, who paid $46,000 for it.

The *Cleopatra*, with a cargo of cotton, had been recently purchased by the Old Dominion Line when it collided with the *Crystal Wave*. Both ships were lost. *Courtesy of The Mariners' Museum, Newport News, Virginia.*

The sun was lightening the dark, clear sky on the morning of October 29 when the bridge watch aboard the *Cleopatra* noted the red light of an approaching steamship. It was the 588-ton *Crystal Wave*, which was known as a swift steamer. The ship should have passed through that area two days ago, but en route from New York, it had hit a storm so powerful that it retreated to the Highlands of Sandy Hook in New Jersey. It resumed its voyage to Washington, D.C., on October 28.

Suddenly, the watch on the *Cleopatra*'s bridge saw that the *Crystal Wave* was now showing its green light, which meant that it had turned. The two ships were headed right for each other. Dole of the *Cleopatra* ordered the helm swung hard starboard to avoid the collision. In the *Crystal Wave*'s pilot house, Captain Martin saw a "great, black object" in front of him that was so dark and encompassing that he later said he couldn't tell what it was.

The vessels crashed, bow to bow. Although the ships recoiled with the impact, the engines were still running, and the momentum hurled them forward again. This time, the *Cleopatra* smashed into the *Crystal Wave*'s broadside, slicing into its hull. Seawater rushed into the gash, and the ship quickly entered its death throes, careening onto its side. In the crew's haste to abandon ship, two lifeboats were destroyed.

Lifeboats from the *Cleopatra* ferried away the *Crystal Wave*'s thirteen-member crew, all except for Martin, who refused to abandon ship. Just fifteen minutes after the collision, the *Crystal Wave* plummeted below the sea, creating a suction so powerful that the crew in the rowboat strained at their oars to escape being sucked under with the ship. Martin was later found alive amid the wreckage.

Water was rushing into the *Cleopatra*'s badly wounded bow, flooding the cargo compartments, and the ship was soon submerged up to its upper decks. The only reason it stayed afloat so long was attributed to its cotton cargo, which helped keep it buoyant. Realizing that the ship was lost, the twenty-six-member crew took to lifeboats. The men drifted for about an hour until the Old Dominion steamship *Kanawha*, bound from Newport News, Virginia, to New York, came upon the scene, and the men gratefully clambered aboard.

The *Kanawha* attempted to tow the *Cleopatra*, but it was too low in the water, and Dole finally said that they should give up the effort. Alone, the *Cleopatra* remained partially afloat, and then it, too, slipped beneath the surface. Captain Joseph Sears of the *Kanawha* would later receive a silver medal from the U.S. Life-Saving Service for his successful rescue of the two ships' crews.

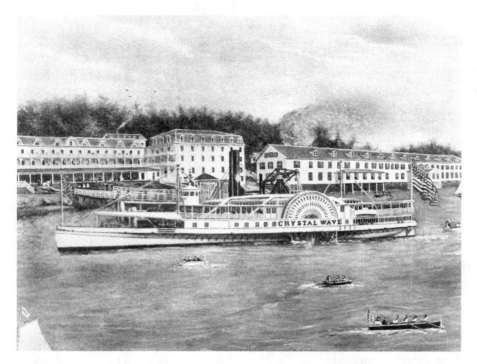

Built in 1875, the *Crystal Wave* was on its way to a new owner in Washington, D.C., when it collided with the *Cleopatra*. *Courtesy of The Mariners' Museum, Newport News, Virginia.*

Fast forward to July 4, 1994. While diving on an unidentified wreck, author Gary Gentile discovered a brass sheet partially protruding from the sand. After working it free, he discovered that cutouts on the sheet spelled out SS *Cleopatra* E.D. He theorizes that the "E.D." stands for Engine Department. In 1995, Captain Sammy Still found the remains of a paddle steamer near the *Cleopatra*. To date, it has not been positively indentified. But few doubt its origins.

THE *MANHATTAN* AND THE *AGNES MANNING*

On November 20, 1889, there were four lifeboats and a life raft, each capable of holding thirty people, aboard the *Manhattan*, a 228-foot-long iron steamer en route from New York to West Point, Virginia. It should have been more than enough to handle the three steerage passengers and the crew of thirty-nine in the event of a disaster.

It wasn't.

At 5:00 a.m., about eight miles from the lightship over the Fenwick Island Shoal, the *Manhattan* collided with the *Agnes Manning*, a coal schooner bound for New York from Baltimore. Eleven people on the *Manhattan* lost their lives.

The *Manhattan*, part of the Old Dominion Steamship Line, was built in 1879 at John Roach's shipyard in Chester, Pennsylvania. About 1879, the ship experienced a collision with the ferryboat *Pavonia*. Both had minor damages.

The passenger freighter left the New York pier about 3:45 p.m. on November 19 with 200 tons of general merchandise and the passengers. The 1,525-ton ship encountered heavy rain soon after departing, but it started to clear about 9:00 p.m., and by midnight the stars were shining.

Captain N.H. Jenny, a sixteen-year-veteran of the Old Dominion Steamship Line, retired to his cabin about 1:00 a.m. Fighting headwinds, the *Manhattan* steamed along its course at between ten and twelve knots. Just before 5:00 a.m., the ship's lookout spotted the lights of a four-masted schooner, the *Agnes Manning*.

Owned by Amos Birdsall, the schooner was built in March 1886 by the New England Shipbuilding Company in Bath, Maine. The 877-ton ship's home port was Perth Amboy, New Jersey, and on that day, it was under the command of Captain C. Birdsall.

Upon seeing the ship, the second officer aboard the *Manhattan* rang the bell, signaling the need to slow the engines. He also blasted the ship's whistle to alert the schooner. Awakened and half-clad, Jenny bolted from his bed. It was too late. Before he could turn the doorknob of the pilothouse door, the ships collided.

The schooner, which was moving at between seven and ten knots, struck the steamship at its port bow, wedging its own bow at the site of the collision and sending the *Manhattan*'s forerigging tumbling to the deck. The steamship's momentum brought the schooner around, giving it leverage to create an even larger hole three feet above the waterline. The purser later said that the *Agnes Manning* hit the *Manhattan* a total of three times.

Because the gash was above the waterline and the steam engines were not leaking, it was thought that the *Manhattan* could continue to a safe port. Then the bow began rolling into the water. The panicked crew had difficulty clearing the lifeboats. Once in the water, one capsized. As the bow tilted, men flew into the sea. The purser and eight others barely made it to the life raft, located on top of the afterhouse. In a lifeboat, Jenny struggled to help a sailor into the boat, but he lost his balance and fell into the water, and

the powerful vortex of the sinking ship sucked him under. He resurfaced, floating for about ten minutes before being rescued.

For thirty minutes, the captain's boat navigated the wreckage, picking up survivors. The men on the boat spotted a quartermaster and the chief engineer clinging to the mainmast, which stuck three feet out of the water. The quartermaster's rescue was accomplished without difficulty, but just as the captain reached for the chief engineer, a large wave crashed over the man, pulling him from the mast. Jenny managed to grasp the engineer's clothes and pulled him toward the boat. Unfortunately, he was already dead.

The schooner *Charles F. Tuttle* rescued some of the men, and at 7:30 a.m. another schooner picked up others. The *Agnes Manning*, meanwhile, was thought to have made it to a safe port with the help of a tug, according to a *New York Times* article. But U.S. Life-Saving Service accounts say that it later sank.

The crew of *Agnes Manning* claimed that its lights were burning brightly and that it should have been seen one to one and a half miles away. The *Manhattan's* lookout, therefore, was defective, they maintained. The *Manhattan* asserted that it changed its course but that the *Agnes Manning* then later changed its course, which therefore caused the collision. The schooner countered that changes were made well before a collision was inevitable. When the *Manhattan* sought damages, the court ruled that the steamer was at fault.

THE *CITY OF GEORGETOWN* AND THE *PRINZ OSKAR*

Lightships and lighthouses were designed to guide ships and illuminate treacherous areas. But on February 2, 1913, a lightship's beacon did quite the opposite. Blinded by the white glare of the lightship on the Five Fathom Bank, the *City of Georgetown* and *Prinz Oskar* collided.

The 599-ton *City of Georgetown* was a wooden schooner built in 1902 by William Rogers of Bath, Maine, a renowned shipbuilder in a town teeming with talented craftsmen. Reportedly, the four-masted *City of Georgetown* was his last ship.

The schooner was en route from New York to Savannah with a crew of eight, including Captain A.J. Slocum, and a cargo of salt. As the ship approached the Delaware capes, it used the lightship to get its bearings.

The 403-foot *Prinz Oskar*, a Hamburg-American liner, was headed from Philadelphia to Hamburg, Germany, with cargo and passengers. After

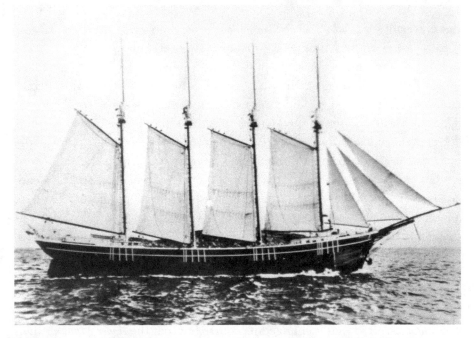

Blinded by a lightship's beacon, the schooner *City of Georgetown* and the steamship *Prinz Oskar* collided, and the schooner began sinking immediately. *Courtesy of The Mariners' Museum, Newport News, Virginia.*

leaving the Delaware Breakwater, the liner was making a wide circle around the lightship to reach a transatlantic lane. At 12:52 a.m., as the *Prinz Oskar* veered away from the lightship, the bridge spotted the schooner. The watch frantically rang the bells, notifying the engine room to reverse the propellers at full steam astern. Simultaneously, the crew aboard the schooner hastened to cut loose the sails, while the helmsman threw the wheel. There was no time. Wind caught the sails and spread them out, and the schooner's bow spirit acted like a "battering ram," the *New York Times* later reported, rocking the liner and slicing into its steel plates as though they were made of tissue.

Most the liner's sleeping sailors and thirty-three passengers were thrown from their bunks to the floor, where they were showered with splintered fittings and ice. On the *City of Georgetown*, the four masts crashed to the deck in a tangle of sails, spars and rigging. When the *Prinz Oskar*'s engines pulled the vessel free, the *City of Georgetown*'s bow spirit separated from its fastenings, and the schooner took a nosedive.

Slocum and the crew had just enough time to launch a dory, although four people had to cling to the sides, their legs dangling in frigid water. When the

City of Georgetown entered its death spiral, the suction yanked the four men from the dory.

Meanwhile, Captain Von Leuenfels of the *Prinz Oskar* was kept busy calming the terrified passengers. Although despairing of finding survivors, he launched a lifeboat into the inky, cold water. All the schooner's crew were saved, including the four who had been sucked into the whirlpool and fortunately resurfaced to ride on wreckage. Two hours after the encounter, the listing *Prinz Oskar* docked in Gloucester, New Jersey.

The court later found the *Prinz Oskar* at fault since as a steamship it should have stayed out of the way of a schooner.

THE *ELIZABETH PALMER* AND THE *WASHINGTONIAN*

In the dark, early morning hours of January 26, 1915, two giants in their respective classes collided. It could have been avoided. Indeed, it *should* have been avoided, and the violent demise of both ships caused repercussions that affected more than the maritime industry.

The regal-looking *Elizabeth Palmer*, one of the largest sailing vessels of its time, was sailing from Portland, Maine, to Norfolk, Virginia, with a light cargo and crew of thirteen, including the steward's wife, who served as the cook. The ship was headed to pick up coal and take it back to Portland.

Built in 1903 by Percy & Small in Bath, Maine, the wooden schooner defined elegance. It was built for shipping magnate William Palmer of Boston, who maintained a fleet of about a dozen ships, and it was later sold to J.S. Winslow & Company of Portland. At three hundred feet long, the five-masted ship weighed three thousand gross tons.

Meanwhile, the *Washingtonian* was on the final leg of its journey from Honolulu toward the Delaware Breakwater after passing through the Panama Canal. Weighing 6,649 gross tons, the freighter was built in 1913 by the Maryland Steel Company of Sparrows Point, Maryland, at a cost of $1 million.

At the time, the *Washingtonian*, owned by the American-Hawaiian Steamship Company, was the largest American freighter, and its refrigerated hold was created to carry salmon from the Northwest to the East Coast. But the state-of-the-art equipment would not get the opportunity to serve that purpose.

On December 30, during its maiden voyage, the *Washingtonian* left Honolulu with ten thousand tons of raw sugar, valued at $1 million, and

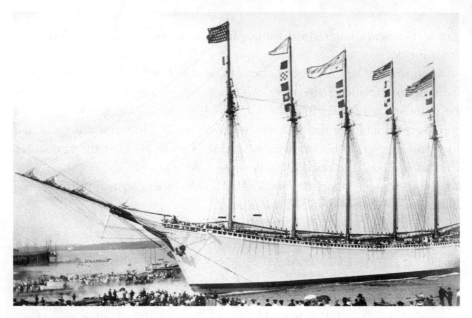

The elegant *Elizabeth Palmer* met its demise on January 26, 1915, at the hands of the *Washingtonian*, considered the largest freighter of its time. *Courtesy of The Mariners' Museum, Newport News, Virginia.*

some merchandise. At about 3:30 a.m. on January 26, 1915, the *Elizabeth Palmer* approached the lightship floating on the Fenwick Island Shoal. The ship was traveling at about eight knots under full sail. It was a clear night with a slight haze over the water.

Then the *Elizabeth Palmer*'s lookout spotted the *Washingtonian* barreling toward the sailing ship at twelve knots. Captain George Carlisle, of Boothbay Harbor, Maine, the master of the *Elizabeth Palmer*, initially was unconcerned. International navigation rules stated that steam vessels must keep clear of a sailing vessel at all times, he later told a *New York Times* reporter. He kept his course.

Captain E.D. Brodhead of the *Washingtonian* was known as an experienced navigator. Brodhead, two quartermasters and a sailor were on the bridge. But something clearly went awry. The steamship did not waver, and the *Elizabeth Palmer*'s bow smashed into the *Washingtonian*'s starboard side, ripping a gaping hole in the freighter and splintering the *Elizabeth Palmer*'s jib boom and foretopmast.

Seawater flooded the sugar cargo of the *Washingtonian*'s upper hold, shifting the ship's center of gravity. Crew aboard the *Washingtonian*, the pearl

of the commercial seas, had just ten minutes to lower the lifeboats into the water and abandon ship before it sunk like a stone to the bottom of the ocean. The men were later picked up by the *Hamilton*. All, that is, except for the watertender, Herman Meyer, who was last seen on deck when the crew lowered the lifeboats. No one ever saw him again.

Carlisle—who in January 1914 lost the *Prescott Palmer* when a storm swept it out to sea, forcing its abandonment—initially hoped that the *Elizabeth Palmer* would stay afloat, but by 4:00 a.m. he ordered the crew to board the lifeboat and head to the Fenwick Island Life-Saving Station. At last glance, the top of the schooner's rail was level with the water. This was not the ship's first collision. On December 27, 1907, the schooner collided with the *Estelle Phinney* off Barnegat, New Jersey, killing one of the smaller vessel's ten-man crew. After that collision, the *Elizabeth Palmer* had been repaired and returned to service.

But this disaster would be the *Elizabeth Palmer*'s last. Cutters' and tugs' attempts to tow the schooner were futile, and it capsized. The ship today is about ninety feet underwater, the row of its ribs providing a playground for lobsters, fish and divers.

With the Cuban sugar crop 200,000 tons behind 1914 figures, the sugar market acutely felt the loss of the *Washingtonian* and its cargo. Since the ship was fully insured, the American-Hawaiian Line did not attempt to raise its investment from the seafloor.

In 1916, the Wells Engineering Company devised a complicated albeit innovative scheme to raise the *Washingtonian*, hoping to benefit from a wartime shortage of commercial freighters. In essence, salvagers would pump air into the ship to create a buoyancy that would free it from the seabed and then use the foremast to maneuver it so the port side was level with the surface. Once the ship was on the surface, tugs would tow it—still on its side—to the shallow waters around the Delaware Breakwater, where it would be righted.

The plan must have been met with some dubiousness, because the ship still rests where it sank.

THE *MORENO* AND THE *ENTERPRISE*

Considered one of the most powerful fighting ships of its day, the *Moreno* was just too big for its own good. The 27,600-ton battleship, which had twelve twelve-inch guns, mounted two per turret, was built by the New

York Shipbuilding Company in Camden, New Jersey, for Argentina, which throughout the first half of the twentieth century boasted Latin America's strongest navy. *Moreno* was a dreadnought, which had steam turbine propulsion and a "big gun" armament scheme. The ship received national infamy for its café, which the U.S. Navy frowned upon in newspaper articles that marveled at the café's inclusion on a warship.

The ship made news for many other reasons. The *Moreno*, capable of traveling at more than twenty-two knots, was the object of a dispute between Argentina and the New York Shipbuilding Company, which wanted payment for the extras added to the ship. All was resolved as of February 20, 1915. On March 26, 1915, with a crew of nine hundred, the colossal ship left Philadelphia for Hampton Roads, Virginia, where ship and crew were scheduled to be fêted before returning to the Delaware Bay for a coal cargo destined for South America. Just thirty miles south of Philadelphia, near New Castle, Delaware, the battleship collided with the barge *Enterprise*.

It was like David meeting Goliath. The collision left a hole in the *Enterprise*'s side that let the river water rush in until the deck was awash. The barge's crew escaped before it sank. The seemingly unscathed battleship waited for high tide before meeting the tug *Mars*, which was towing three barges from Boston to Philadelphia.

The relatively uninjured *Moreno* went ashore, remaining fast until 7:30 a.m. the following day, when it was floated. As it turns out, the *Moreno* did suffer damage to its steering gear, which required repairs. About two weeks later, on April 16, the battleship again set out for Hampton Roads. This time, however, it ran aground near Reedy Island. The ship landed atop the upper end of the Dan Baker Shoal, and it stayed fast all that night before being freed and continuing on its way. The ship is remembered for its cutting-edge design. The *Enterprise*, however, is barely a blip on the maritime screen, yet another casualty on the Delaware River.

WRECKS IN REHOBOTH

DOUBLE TROUBLE: THE *MERRIMAC* AND THE *SEVERN*

Compared to Lewes, which was established in the seventeenth century, Rehoboth Beach is a youngster. The town was founded by Reverend Robert W. Todd of St. Paul's Methodist Episcopal Church in Wilmington, who was enthralled by what was then known as "camp" or "tent" meetings in New Jersey: Christian gatherings that brought people together from such far-flung areas that they camped out for a lengthy period of time, such as over the summer.

Officially born in 1873 as the Rehoboth Beach Camp Meeting Association of the Methodist Episcopal Church, the town was more about religion than it was about maritime industry or seaside tourism. The Camp Meeting Association disbanded in 1881, and in 1891 the city became Cape Henlopen City. In 1893, it was named Rehoboth Beach, and it quickly became a tourist spot. Charles Horn in the late 1880s built an emporium on a pier that jutted into the ocean from the existing boardwalk that was known as Horn's Pavilion. There was a recreation room, a dance hall and a theatre.

Rehoboth means a "place for all," but there was no room for the two monsters that occupied its beach in 1918. On April 8, 1918, the tug *Eastern* left New York for Norfolk, Virginia, with three barges, including the *Severn* and the *Merrimac*. Twenty-four hours later, near the Delaware capes, the tug encountered stormy seas that prompted it to head toward the safety of the Delaware Breakwater. Perhaps owing to the winds, the tug's course strayed too far south. By 9:30 p.m., the weather took a brutal turn for the worse, and the tug righted its course for the breakwater.

In 1918, the *Merrimac* and the *Severn* broke free of the tug that was hauling them and flew onto the beaches at Rehoboth Beach, creating a tourist attraction whose appeal waned as officials considered the approaching summer season. *Courtesy of the Delaware Public Archives.*

Between 4:00 a.m. and 5:00 a.m., on April 10, the order came down to "let go stern," indicating that at least one of the barges should be cut free to anchor. The order came again, and the tug let go of the *Merrimac*, which could not hold its anchor and drifted toward the shore of Rehoboth Beach. The third barge, the *Severn*, also couldn't find anchorage. It, too, drifted toward the shore.

The 640-ton *Merrimac*, built in 1906, slid to a stop in front of St. Agnes by the Sea. Located at the end of Brooklyn Avenue, the facility was a home maintained by the Franciscans for nuns who taught in Delaware Catholic schools. The *Severn* skidded onto the beach not far from its neighbor.

To say the least, the ships' landing ashore was quite the sensation, rivaling the amusements on Horn Pavilion. The two ships looked like gigantic beached sea monsters, colossal creatures out of their element on the shore. Some people were able to board the *Merrimac* for a ship's-eye view. A photograph of two lucky gawkers shows a woman who has stepped onto a crudely built platform on deck. The wind has whipped her dark skirt back from her neatly buttoned boots, and a man, holding his hat, grasps her wrist to steady her.

The sweetness of the off-season tourist attraction soon soured. The barges' position, right at the end of the boardwalk's major recreation area, made for

an eyesore, especially since the summer season was but a month or so away. A tug managed to float the *Severn* from its new bed, but the *Merrimac* was too damaged to pull free from the sand, where it had embedded itself. Salvagers stripped away all but the hull, which was left to settle deeper into the sand. At low tide, its remains could prove a danger to swimmers, and the town posted signs prohibiting swimming in that area.

BURL IVES COMES TO VISIT

With its proximity to Washington, D.C., the Delaware coast is no stranger to celebrity sightings. Legislators, socialites and actors have long made the seaside towns their summer playground. But on October 6, 1957, Rehoboth Beach received an unexpected and unusual brush with celebrity.

Legend has it that folk singer Burl Ives and his crew were sailing his $100,000 yacht, the *Black Spoonbill* from New York to Palm Beach, where he had a singing engagement. The television and motion picture star was then best known for his role in *East of Eden*, which he would follow up in 1958 with his role as Big Daddy in *Cat on a Hot Tin Roof*. In 1964, he provided the voice of the snowman in *Rudolph the Red-Nosed Reindeer*.

The yacht hit a storm that forced it aground on Rehoboth Beach. Still according to legend, the dapper Ives refused the aid of rescuers, preferring to swim to shore. Later, while recovering at a bar, someone asked Ives how he remained so debonair in the face of such danger. Ives raised a glass of whiskey and responded, "Gentlemen, when you're struggling and when you've got pain, that's when you know you're alive."

The truth, however, is much different. Ives was not aboard the yacht when it encountered the rapidly moving storm, which affected the area from Cape Hatteras, North Carolina, to Provincetown, Massachusetts. The Coast Guard rescued the six-man crew of the *Black Spoonbill*, a sixty-two-foot auxiliary kvetch. Two crew members suffered injuries and were taken to Beebe Hospital in Lewes.

Ives supposedly came down to inspect the damage, and gossip reporters noted that he ate at the Dinner Bell, a local restaurant. Until it was moved, however, the yacht was the main attraction. Crowds of people happily stood on the beach, hands in pockets, hair whipping in the wind and skirts flapping, to gawk at the vessel, which with its torn sails resembled a pirate ghost ship. Photos of the wreck are preserved in the Delaware Archives.

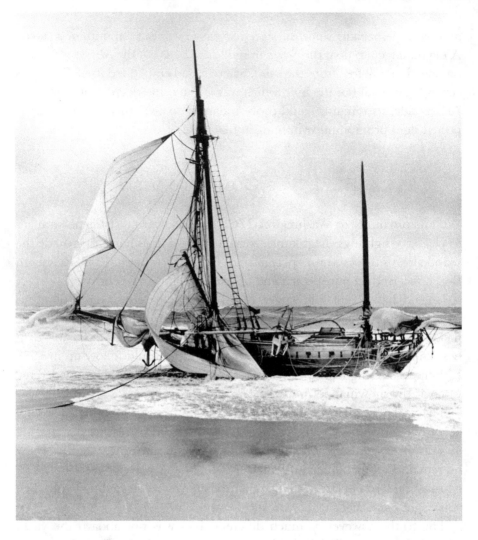

Actor and singer Burl Ives's yacht, the *Black Spoonbill*, created a celebrity sensation when it landed on Rehoboth Beach during a storm. *Courtesy of the Delaware Public Archives.*

DELAWARE'S MOST SPECTACULAR SHIPWRECK

The remains of the *Merrimac*, a barge beached during a storm in 1918, were still visible when company came a calling in the form of what one writer would call "Delaware's most spectacular shipwreck."

It was the *Thomas Tracy*, a 7,143-ton, 250-foot Coast Guard freighter, which was heading south from New England when it came face to face

with the Great Atlantic Hurricane of 1944, one of the costliest twentieth-century hurricanes. The storm resulted in 390 deaths—344 of which were at sea—and caused more than $1 billion in damages.

The hurricane was first spotted on September 9, northeast of the Lesser Antilles, and it intensified about the time it reached the Bahamas. "A great hurricane fraught with peril for life and property is bearing down on the North Carolina coast; only a last-minute change of direction could save the coastline from a raking by winds of a force comparable to the New England Hurricane of 1938," reported the *Philadelphia Inquirer*.

It was a devastating storm that had already claimed the life of the USS *Warrington*, which steamed right into the storm's fury. After leaving Norfolk, Virginia, to escort the USS *Hyades* to Trinidad, the *Warrington* abandoned the escort near the Bahamas in search of calmer seas. On September 13, beaten by the brutal seas that tore off its cowlings and vents topside, the ship began taking on water and shortly thereafter lost power, electricity and steering. The crew abandoned the ship, which sunk. Of the 321 men aboard, 248 lost their lives.

By the time the hurricane hit Cape Hatteras, North Carolina, on September 14, its radius topped 500 miles. Barometric pressure plummeted to 27.97 inches as 110-mile-per-hour winds howled around the cape. Winds soared to more than 124 miles per hour as the storm muscled its way near Cape Henry, Virginia.

Due to U.S. Weather Bureau warnings that dangerously high tides would sweep Ocean City, Maryland, three buses with up to 300 vacationers headed for Salisbury, leaving 1,200 residents behind. The storm passed less than one hundred miles east of the resort between 3:00 p.m. and 4:00 p.m. and lifted sections of the boardwalk off the moorings. Oceanfront hotels flooded and seawater rushed through streets at a depth of three feet or more.

It was a similar scene in Rehoboth Beach, which was pelted with rain and shaking with winds that gusted up to ninety miles per hour. At Cape Henlopen, the roofs of houses were blown away by the intense winds. The Red Cross evacuated thirty-five children from the Children's Beach House near Lewes.

Into the mêlée steamed the *Thomas Tracy*, which had previously been known as the *Condor* and the *Begna*. Built in 1916, the Coast Guard ship had survived threats from German U-boats, but it was no match for the hurricane. The high winds and rolling seas conspired to push the heavy vessel toward the beach, where it skidded to a stop about one hundred yards from shore right on top of

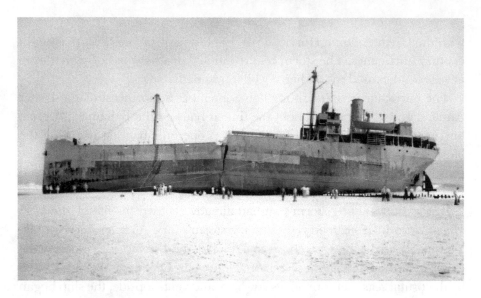

Its colossal size, prominent position on the beach and photogenic qualities prompted many to call the broken *Thomas Tracy* Delaware's most spectacular shipwreck. *Courtesy of the Delaware Public Archives.*

the remains of the *Merrimac*. While waves careened over the decks, the crew of thirty-one attempted to save themselves. They attached a line to a life raft and dropped it into the water, where waves carried it to shore. Citizens on the beach scrambled to the raft, untied the line and reattached it to a telephone pole. Before the crew could test the makeshift rescue device, the Coast Guard arrived with a Lyle gun and fired a line over the ship. The crew caught it on the first try and readied the breeches buoy to transport them one by one to the beach.

It was a transfer fraught with terror. The ship quaked in the water, groaning as the pressure from the waves niggled at the damaged hull, creating cracks. Only six men had safely used the breeches buoy when a sickening sound, like a shot, pierced the wind. The ship had literally split in two. All of the men, however, made it safely to shore.

The storm ripped up the coast, churning up a forty-foot-high tidal wave in Cape May, New Jersey, that washed away pieces of the boardwalk and the convention hall. Along with the *Thomas Tracy* and the *Warrington*, the storm claimed two Coast Guard cutters, the *Bedloe* and *Jackson*, the *Vineyard Sound Lightship No. 47* and the minesweeper YMS 409. After passing over Providence, Rhode Island, the hurricane veered out to sea and died.

The *Thomas Tracy* was a complete loss. Wreckers cut the ship down to the waterline, which had also been the case with the *Merrimac*. Because both

remains are hazardous to swimmers, the area has been cordoned off. Beach replenishment programs have buried the ships' bones farther below the surface. Storms, however, keep threatening to open their graves.

MILITARY CASUALTIES

DELAWARE DOES ITS PART

Delaware earned the moniker the "First State" when on December 7, 1787, it was the first state to ratify the U.S. Constitution. The Small Wonder continues to take an active political role in some fashion or another, particularly when it comes to the country's defense. The most obvious example today is the location of the Dover Air Force Base in the center of the state.

Then there is the still strong presence of the DuPont Company, which was originally started in 1802 as a black powder works. During the War of 1812, DuPont sold half a million pounds of black powder to the U.S. government. The quality of the product was so well known that by 1834 exports accounted for 20 percent of the company's production.

The military and the local businesses that served it capitalized on the state's proximity to Washington, D.C., Philadelphia, Baltimore and New York, as well as its location on the Delaware River. The enemy, however, also saw the advantages, especially when it came to coastal warfare.

During the Revolutionary War, the British blockaded the mouth of the Delaware to inhibit trade and conduct raids on the coastal towns, which instilled fear in the residents and disturbed commerce. The British returned in March 1813 during the War of 1812. As before, the British blockaded the Delaware Bay and the Delaware River and conducted raids along Delaware's coast to bring shipping trade to a sputter. To protect itself, Lewes had two fortifications, cannons mounted on earthworks, under the command of Colonel Samuel Boyer Davis. There was one in Pilot Town and one along the canal.

In March 1813, the British commander, John P. Beresford, sent a note to town representatives demanding twenty live bullocks, vegetables and hay or he would destroy the town. Remembering his manners, Beresford signed his note with "I have the honor to be, sir, your very obedient servant." The town refused to give supplies to the British, who were, to say the least, not pleased. In retaliation, the frigate *Poictiers*; a ship of the line, *Belvidere*; and a schooner moved into bombardment positions. On April 6 and 7, the ships pummeled the town from the harbor, an onslaught that lasted twenty-two hours and included up to eight hundred projectiles.

In many respects, these were shots in the dark. Trees from the marshy area along the beach obstructed the view. But there was plenty of noise and fear. Still, troops firing back at the British were determined to keep the British from succeeding. The three British ships moved on, but the blockade remained. In Lewes, the 1812 Memorial Park, located along the canal just before the bridge, commemorates the defense of Lewes against the two-day bombardment.

During the Civil War, Fort Delaware, which dates back to 1859, became a Confederate prison. The fort is located a short ferry ride from Delaware City on Pea Patch Island, which reportedly received its name after a ship struck the island, spilling a cargo of peas.

At the onslaught of both World War I and World War II, government officials realized that the beaches offered plenty of barren, uninhabited areas that might invite the enemy to come ashore. While the Germans never launched an attack on land, they did come surprisingly close to shore, and their presence proved devastating for both military and civilian ships.

To guard the coastal areas, the government in 1941 built Fort Miles, located on about 1,300 acres on the site of what is now Cape Henlopen State Park. The first troops were from the 261st Coast Artillery, a Delaware National Guard Unit. At its peak, there were about two thousand troops stationed in eighty-three barracks and sixty tents. About three to four hundred German prisoners of war were also kept at the fort.

The fort contained two sixteen-inch guns and two twelve-inch guns. Among its most intriguing structures are the watchtowers positioned along the coast. The concrete towers, which vary from thirty-nine to eighty-one feet, were equipped with optical instruments for acquiring and observing targets. The most common was the azimuth sighting telescope, mounted on concrete columns inside each tower and positioned so that viewers could see through the tower's slits. These scopes were used to determine the position

of a target. (An azimuth is a measure along the horizon of the angle between an object and a reference point.)

The arrangement, however, was not designed to target U-boats. The towers instead were created for artillery fire control and for pinpointing the location of shell splashes to ensure that guns were accurate. Basically, the fort was all about protecting the coast in case of a land attack. Nevertheless, the observation points—located in the towers' upper slots—did make for ideal lookouts.

Though heavily armed, Fort Miles would never see major action, and its watchtowers could do nothing to save the USS *Jacob Jones*, one of the first military ships to suffer from the U-boat activity off the coast.

A HERO BEGETS A HERO

Born in Smyrna, Delaware, Commander Jacob Jones was an early eighteenth-century war hero who survived twenty months as a prisoner of war and went on to command the USS *Wasp* in the War of 1812. The *Wasp* was famed for its capture of the British twelve-gun brig HMS *Dolphin* and the defeat of the sloop HMS *Frolic* off the Delaware capes.

The navy would name three ships for Jones, who went on to become commander of the U.S. Naval Forces in the Pacific in 1826. But fortune did not smile as broadly on two of the three vessels as it did on their namesake. Both were destroyers built by the New York Shipbuilding Corporation in Camden, New Jersey, and both met with disaster.

The first *Jacob Jones*, built in 1915 and commissioned in 1916, primarily patrolled the Virginia coast prior to the United States' April 1917 entry into World War I. In May 1917, the ship began anti-submarine patrols and convoy escort work out of Queenstown, Ireland, rescuing survivors of torpedoed ships until December 6, 1917, when it became a victim of a torpedo itself. En route from Brest, France, to Queenstown, the ship was torpedoed and sunk by the German submarine *U-53*. The *Jacob Jones* sank in eight minutes, taking sixty-four lives with it. Thirty-eight sailors survived because the commander of the U-boat, Kapitanleutnant Hans Rose, transmitted the coordinates for British rescue vessels to hear.

The second *Jacob Jones* was a four-stack, flush-deck destroyer launched in November 1918—too late to see action in World War I. The ship was decommissioned from 1922 to 1930, and then it cruised the Atlantic,

The USS *Jacob Jones*, the second navy ship to receive that name, was torpedoed off the Delaware coast in 1942 on its way to patrol and protect the mid-Atlantic waters. Its predecessor was torpedoed in World War I. *Courtesy of the Delaware Public Archives.*

Caribbean and Mediterranean during the Spanish Civil War. By then, the *Jacob Jones* was considered old and possibly obsolete. Indeed, the navy had already disposed of some of the *Jacob Jones*'s sister ships and traded others to England for ninety-nine-year leases on military bases in the British Isles.

Like its namesake, the *Jacob Jones* continued to survive. Initially, the ship handled escort duty between Newfoundland and Iceland. But when German U-boats threatened the East Coast in 1942, the *Jacob Jones* headed to the mid-Atlantic to become part of America's Neutrality Patrol, which emphasized the navy's readiness to defend the western hemisphere.

Lieutenant Commander Hugh Black had been at the helm since 1941. A 1926 graduate of the U.S. Naval Academy, the handsome Oradell, New Jersey native had been the executive officer of the destroyer *Benson* from 1940 to 1941. He was thirty-eight when he took command of the *Jacob Jones*, which some of the crew nicknamed "Jackie." On Black's first venture aboard ship, he dropped fifty-seven explosive canisters in twelve attack patterns when the soundman suspected that a U-boat was in the area. Despite the appearance of oil slicks, there was never a sign of a U-boat.

On February 27, 1942, the *Jacob Jones* left New York after rearming. Shortly after leaving for its mid-Atlantic patrol area, the ship passed the remains of the *R.P. Resor* off Asbury Park, New Jersey. The 7,451-foot tanker—built in

1936 by the Federal Shipbuilding and Drydock Company of Kearney, New Jersey, for the Standard Oil Company—had been heading from Houston to Fall River, Massachusetts, with 78,729 barrels of crude oil when it was torpedoed by *U-578* on February 26.

The *R.P. Resor* burned for two days. Between the hot flames and the oil-coated, frigid seas, the chances for survival were dim. Forty-eight men perished in the conflagration. The two who survived were so soaked with oil that rescuers had trouble holding on to them. One even had a blob of oil in his mouth. The *Jacob Jones* searched for survivors for two hours. It would find none, and the ship continued on its mission.

At 5:00 a.m. on February 28, the sky was still dark, although a full moon pulsed in the dark sky. All was quiet. Suddenly, two torpedoes struck the ship, one after another in rapid-fire succession. One hit under the bridge on the ship's port side, apparently detonating under the forward magazine; the other hit under the stern. Like the *R.P. Resor*, the *Jacob Jones* had fallen victim to *U-578*.

The impact tossed the ship right out of the water. The bridge was completely wiped out, and the bow was severed forward of the No. 2 boiler room. The explosion shaved forty feet of stern down to the keel. Nearly one hundred men and all but one officer were killed, including Black.

Gary Gentile in his book *Shipwrecks of Delaware and Maryland* recounts the horror: "Topside the scene was one of utter devastation. The decks were covered in oil, small fires flared here and there, and wounded men stumbled about without benefit of a command structure. Assistant Engineer Ensign Smith, the only living officer on board, 'was so badly injured that he was practically incoherent.'"

Because of the watertight bulkheads, a portion of the ship stayed afloat despite its missing sections. Its death, however, was inevitable, and the survivors needed to think fast. The lifeboats were jammed in their fittings, and life rafts were covered in debris. As the ship slowly settled in the water, the crew hastened to unearth the life rafts, which they pushed overboard. They jumped in after them, and once in the water, some men clambered in them while others clung to the sides.

The ship started to go down, the stern rising in the water. Then, suddenly, water shot into the air like a colossal fountain. The depth charges were going off, the force of which killed men who were too close to the destruction. Others suffered internal injuries from the concussion.

At 8:45 a.m., an army patrol plane spotted the debris and the life rafts, and a ship proceeded to the site. Out of 145 men, only 11 survived. On August

10, 1942, while cruising the North Atlantic, seeking more victims, *U-578* was attacked by Czechoslovakian Squadron 311 and destroyed, taking its crew with it to the bottom.

Black, who had a wife and baby, followed in the footsteps of the real Jacob Jones. In 1943, the navy paid tribute to him with the commission of the destroyer USS *Black*. The third USS *Jacob Jones* was launched in 1942. It was decommissioned in 1946 and sold for scrap in 1973.

CAUGHT IN THE FIRE

Military vessels were not the Germans' only target. U-boats routinely frequented shipping lanes, targeting supply ships. The *Hvoslef* became one of the victims. Managed by Helmer Stauber & Company in Oslo, Norway, the 1,630-ton fruit freighter was built in 1927 by Swan, Hunter & Wigham Richardson in England, the famous shipbuilding company that also built the RMS *Carpathia*, which rescued survivors of the *Titanic*.

Beginning in March 1940, the 255-foot-long fruit carrier was chartered to the United Fruit Company, and on March 10, 1942, the ship was traveling between Sagua La Grande in Cuba and Boston with a load of sugar. The ship, commanded by Captain Arthur Dahl and carrying a crew of twenty, was unescorted and unarmed.

Underneath the water, just off Fenwick Island, *U-94* waited. The vessel was a Type VIIC U-boat, often considered the workhorse of the fleet and built by Germaniawerft in Kiel, Germany.

The *Hvoslef* was clipping along at thirteen knots, headed north. The skies were clear and the sea had some light chop. About 9:05 p.m., the second mate on the bridge thought he spied a submarine off the starboard beam. He barely had time to alert the master when the first torpedo struck, pulverizing the stern. A second torpedo, fast behind the first, struck the starboard side.

Five men were killed instantly, and within two minutes, the ship sank. Survivors had managed to launch a lifeboat, and they kept themselves afloat, praying for rescue, for fourteen hours. Seeking more survivors after rescuing the men in the lifeboat, planes and cutters crisscrossed the area, which was ominously marked by debris and an oil slick. Directed by aircraft, the fishing boat *Karla* would find a man on a cork raft two days after the calamity. It was Captain Dahl, who had died from exposure.

Traveling between Cuba and Boston in 1942, the Norwegian fruit freighter *Hvoslef* became a victim of the German U-boat campaign along the East Coast. *Courtesy of The Mariners' Museum, Newport News, Virginia.*

By 1942, the *U-94* had sunk more than twenty ships. On August 28, 1942, while preparing to attack a convoy in the Caribbean, *U-94* was spotted by U.S. Navy *Catalina*, an airplane with depth charges. The plane's attack forced the *U-94* to surface, whereupon a Canadian ship fired on the submarine. Twenty-six survivors, including the captain, were taken to Guantanamo, Cuba.

FACING THE ENEMY

The demise of USS *Jacob Jones* and the *Hvoslef* were part of the German navy's East Coast attack, known as Operation Drumbeat. As early as January 14, 1942, the submarines were picking off victims. The first, the *Norness*, was a Norwegian-owned, Panamanian-registered diesel screw motor-tanker torpedoed by *U-123* off Montauk Point, Long Island. On January 25, the Norwegian tanker *Varanger* was sunk near the Delaware Bay, about twenty-

eight miles east of Wildwood, New Jersey. The USS *Jacob Jones* was another early casualty. *Unterseeboots*, or U-boats, were menaces that swiftly took on monster-like proportions in the minds of coastal residents and those assigned to protect the coast.

Since many ships were destroyed so close to shore, Delawareans often witnessed the attacks. In a July 10, 1991 article in the *News Journal,* an old-timer talked about folks sitting on Bethany Beach, watching ships explode at sea.

Lewes was a haven for many sailors from torpedoed ships. On May 14, 1945, however, the residents came face to face with the enemy. The German navy on May 4, 1945, announced that all hostilities were to cease the next day. *U-858* at that time was in Canadian waters. Built in 1942 and commissioned on September 30, 1943, the U-boat was commandeered by twenty-seven-year-old Kapitanleutnant Thilo Bode. With a crew of fifty-seven officers and men, *U-858* headed to American waters to surrender. The U-boat established communications with U.S. station OZZ110 on May 9 and gave the station the U-boat's position, course and speed.

In May 1945, *U-858* surrendered to the U.S. Navy. The U-boat's crew was taken to Fort Miles, the military base located near Cape Henlopen, and the vessel went on to the Philadelphia Naval Yard. The USS *Pillsbury* is in the distance. *Courtesy of the Delaware Public Archives.*

Ordered to surface and run up either a black or white flag, Bode had his shower curtain painted black and affixed it to the ship. He had all the ammunition and barrels of the twenty-millimeter cannons thrown overboard. USS *Carter* and USS *Muir* met *U-858* on the morning of May 10, 1945. The ships approached the sub with some trepidation; a fog made it difficult to view the flag. The destroyers USS *Pillsbury* and USS *Pope* placed a prize crew aboard the sub to search for the crew and accept their surrender. Since Cape May was too shallow, the ships headed to Lewes and Fort Miles.

While United States sailors craned their necks from their vessels to watch, the U-boat's crew moved to the rescue tug *ATR-57*. *U-858* was anchored at Cape Henlopen before heading on to the navy yard at Philadelphia. Newspaper photos gave Americans an up-close look at the inhabitants of the metal monster they had feared for so long. The men, however, looked young, skinny and harmless. Captured in one photograph, Bode was seen with a cigarette dangling from his mouth, arms casually crossed at his waist. He was later taken to Washington, D.C., for interrogation. Many of the captured Germans did not return to their homeland until 1948.

The surrender made *U-858* the first enemy warship to surrender to the United States since the War of 1812.

BLOWN TO BITS

June 24, 1942, started as a good day for the crew of the *John R. Williams*, a civilian tug leased by the navy for salvage and rescue work. The tug had pulled the *Port Darwin*, a British freighter, off Fenwick Island Shoal, and afterward it followed as the steamship was escorted by the *YP-334* toward the Delaware capes.

The *YP-334*, which was armed, was charged with protecting vessels during salvage operations. U-boat sightings were not unusual, and ships often traveled together close to shore, where U-boats were more easily visible. Indeed, the *Port Darwin* had been part of a convoy when it and another ship were stranded on the shoal, but that convoy had moved on when the two ships ran aground.

As the *Port Darwin* and *YP-334* made their way north, the tug chugged behind at eleven knots. Built in 1913 by the Staten Island Ship Building Company in Port Richmond, New York, the 396-ton tug was previously named the *W.B. Keene*. It was owned by the Great Lakes Dredge & Dock Company of Chicago, and the vessel undoubtedly received a new name to

honor John R. Williams, formerly Great Lakes' top engineer, who became president of the company in 1935. He died a month later. In 1942, the tug was managed by the Moran Towing Company.

Relieved of their watch, Chief Engineer William Lacoy, Second Assistant Engineer Harold Jorgensen and seamen William Balfour and Homer Pendleton sat on deck, chatting. Suddenly, the tug quaked and all four men were catapulted into the air and out into the water. Jorgensen caught a quick glimpse of the tug, which he later said "appeared to be heading down into the water and to have been blown to bits."

After striking a German mine credited to *U-373*, the tug was completely pulverized, leaving only a slick of oil along the water's surface and a debris field. When Jorgensen came up for air, he inadvertently swallowed fuel oil. Nevertheless, he pulled himself onto a bobbing mattress, which he later exchanged for a ventilator. Balfour called to him from where he was hanging on a pike pole, and Pendleton managed to climb into a life raft, which Jorgensen headed for posthaste.

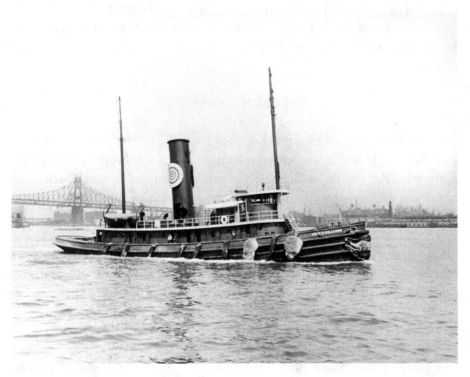

On June 24, 1942, the *John R. Williams* struck a mine and exploded into a mass of debris. Only four men survived. *Courtesy of The Mariners' Museum, Newport News, Virginia.*

The *YP-334*, near enough for its crew to witness the blast, turned to offer aid. The vessel picked up Balfour and rescued the men on the raft. Jorgensen noticed Lacoy in the water, and the crew threw him a line. The four men were the only survivors of the explosion. The other fourteen, including Captain Roy Allen, perished. Once the patrol boat docked in Lewes, the four men were immediately taken to Beebe Hospital.

The Coast Guard quarantined the area between Cape Henlopen, Cape May, Macries Shoal and Fenwick Island until sweeping operations cleared the section of mines.

U-373, commanded by Paul-Karl Loeser, also in 1942 sank the *Mount Lycabettus*, a 4,292-ton Greek steam freighter, and the *Thursobank*, a 5,575-ton British merchant ship. Both sank farther off the mid-Atlantic coast. There were no survivors from either ship.

Under the command of Detlef von Lehsten, the *U-373* would meet its end on June 8, 1944, in the Bay of Biscay, thanks to depth charges from a British liberator aircraft.

TRAGEDY OR TRAVESTY: THE PLIGHT OF THE *CHEROKEE*

Not all military ships were lost as a result of U-boat activity. While heading to Washington, D.C., from Newport, Rhode Island, on February 26, 1918, the USS *Cherokee* got caught in a heavy gale with fifty-mile-per-hour winds and foundered about twelve miles off the Fenwick Island Shoal. The tug went down, and twenty-eight people lost their lives. At first the loss was credited to bad weather. But court of inquiry would determine that humans were as much to blame.

The 120-foot tug was built in 1891 by John H. Dialogue & Sons in Camden, New Jersey. Originally owned by the Luckenbach Steamship Company, the tug was initially named the *Edgar F. Luckenbach*. For the most part, the vessel had a respectable career along the coast. Its only black mark came on December 26, 1913, when towing lines attached to the schooner barges *Undaunted* and *A.G. Ropes* parted, causing the grounding of both ships on the New Jersey shore.

In 1915, the owner wanted to give the tug's name to a brand-new freighter. As a result, the tug was rechristened *Luckenbach No. 2*. Department of Commerce inspectors in October 1916 found that "the steamer is

seaworthy and fully equipped as per law—steamer has had a general overhauling such as scaling and painting interior of hull and all necessary repairs. Boiler engine and pumps were found in fair condition and certain repairs were proposed which when completed would make same lawful and safe." Repairs were completed.

The Third District Section of the Joint Merchant Vessel Board in August 1917 reported that the tug was "an iron seagoing tug, 26 years old, in fairly good state of preservation, now undergoing minor repairs and overhaul."

On October 12, 1917, the U.S. Navy purchased the 272-ton tug primarily to tow large, disabled vessels. When officially commissioned in December, it was renamed the *Cherokee* after the Native American tribe. It was clearly a popular name, as three navy ships wore it. The tug was refitted first at the W&A Fletcher shipyard in Hoboken, New Jersey, and then in the New York Navy Yard, where it received a three-inch, fifty-caliber gun and two machine guns. It then received further alterations at the Philadelphia Naval Yard. In January, the *Cherokee* slowly made its way to New London, Connecticut. The weather was bitterly cold, and ice was a problem in the Long Island Sound. For four days, the tug bucked the ice to work passage northward. Officers inspected the hull and spotted no ice-related injuries, and when the bilges were cleaned, there was no leakage found. Nevertheless, some repairs were made by the Thames Towboat Company in New London.

In Newport, the tug was loaded with coal, water and about four tons of supplies. With its thirty-nine-member crew, the *Cherokee* departed Newport on February 24. The weather was clear during the run to Barnegat, New Jersey, and tug plowed along at a speed of just under ten knots.

The *Cherokee* was under the command of Junior Lieutenant Edward D. Newell, just twenty-three years old at the time, who had a nineteen-year-old wife, Esther, at home. Later, she would report that her husband called the *Cherokee* "an old hulk, unfit for use." She said that he had made several complaints to the department about the ship's "wretched condition."

It was Newell's first command, and no doubt he was alarmed when the weather reports started coming in about 8:00 p.m. by wireless: "Advisory storm warning hoisted. Norfolk to Eastport. Storm central over Indiana moving eastward. Will cause probable brisk to strong southwest gales Atlantic seaboard to-night becoming westerly Tuesday forenoon."

By midnight, the ship had slowed considerably due to heavy seas that forced its bows underwater every fourth or fifth swell. Boatswain Sennett emptied the forward water tank to lighten the vessel. Still, water persistently seeped into

the deck, under the doors and through the bunker plates. At 7:00 a.m., the *Cherokee* attempted to turn to make port, but the steering gear broke down. An SOS call went out at 7:30 a.m.; the tug had taken on too much water. Newell, however, misjudged his distance. He thought he was south of the lightship on the Fenwick Island Shoal when he was actually north of it. Following his directions, the USS *Emerald* from Cape May headed in the wrong direction.

The crew attempted to lower a lifeboat, but the sea roared over the men, sweeping Ensign John Stevenson overboard to his death. At 8:00 a.m., the ship went down, sending the crew overboard. Some made it to the large life raft, some clung to smaller rafts and others clutched wreckage to stay afloat in the tumultuous seas.

An hour later, crew aboard the British tanker *British Admiral* spotted some of wreckage as far as six miles from the disaster. Six bodies floated in the water. At that point, nearly all of the men in the rafts were unconscious. The tanker rescued twelve survivors, but two died of exposure before the tanker reached port. Young Newell was nowhere to be found.

Back then, foreign ships at the mouth of the Delaware River were required to stop at the Delaware Breakwater Quarantine Station, located on land now occupied by Cape Henlopen State Park. The station, which opened in 1884, was part of the federal government's National Quarantine System, an attempt to control large-scale outbreaks of contagious diseases, particularly those carried by immigrants. Ships heading up the Delaware River stopped at the station, which was marked by a quarantine flag. A doctor would board the ship to handle routine medical matters, such as a broken arm, and look for disease. If the doctors spotted no sign of disease among the passengers and crew, the ship proceeded to Philadelphia. Those suspected of disease were taken to the hospital. Later, officials also removed anyone who had come in contact with the patients.

The *British Admiral*, however, broke regulations and steamed to League Island in the Delaware River at the mouth of the Schuylkill River, home to the Philadelphia Naval Yard.

The Navy Board of Investigations and a later court of inquiry reported that the tug was a small, old vessel in poor state of repairs that was overloaded. The commanding officer, the board maintained, failed to take proper precautions. He should have turned back when he learned of the storm, and he should have formed a bucket brigade when the pumps could not keep up. He also should have shifted the nine thousand pounds of ammunition kept in the magazine.

Not surprisingly, the judgment did not sit well with Newell's father, Dr. George Newell, a dentist in Gloucester, Massachusetts. His own investigation uncovered the fact that experts at the Philadelphia Naval Yard had deemed the ship unfit for distant service. A vessel meant to cross an ocean, he noted, should not founder at sea.

As author and diver Gary Gentile points out, World War I occupied the mind of the military and the public at that time. There were far greater casualties to consider than the death of the *Cherokee*'s crew. For years, the wreck site has been known as the Gunboat because of the deck gun on the bow. No matter the name, it was a tragedy that in some minds could have been prevented.

THE SUN SETS ON THE "MOON"

Like the *Cherokee*, the USS *Moonstone* was just in the wrong place at the wrong time. The navy vessel was involved in a collision, and in this case, the other ship was also a military vessel.

Before joining the navy in 1929, the *Moonstone* was a socialite's plaything, a plush yacht owned by George Galt Bourne, son of Commander Frederick Gilbert Bourne, founder and president of the Singer Manufacturing Company and an avid yachtsman.

The 469-ton, steel-hulled vessel was built by Germaniawerft in Kiel, Germany, a prestigious company that primarily gained fame for its building of U-boats in World War I and World War II. The yacht was once an attractive ship, with neatly draped lifeboats, a motorboat and plenty of shady spots in which guests could take shelter but still take in the view. The lounge boasted a tony fireplace with gleaming wood trim, sconces, a handsome beamed ceiling and cushy armchairs. It was the perfect place to loll away the evening hours after a New England sail.

The vessel reportedly had several names, including the *Nancy Baker* and the *Mona*. Bourne sold the yacht to financier Frederick H. Prince in 1933, and by the time Prince sold it to the U.S. Navy on February 10, 1941, the yacht was best known as the *Lone Star*. At that time, the U.S. Navy was short of patrol craft and needed to restock at the onset of the United States' involvement in World War II.

The yacht, however, had already seen action. On August 13, 1937, off Gould Island in Rhode Island, the submarine USS *Cachalot* fired a torpedo that passed between Vincent Astor's yacht, *Nourmahal*, and the *Lone Star*. The

Once a luxury yacht known as the *Lone Star*, the USS *Moonstone* met its end on a foggy night in 1943 when it collided with the destroyer USS *Greer*. *Courtesy of The Mariners' Museum, Newport News, Virginia.*

torpedo struck a ledge, leapt into the air and plowed through an iron fence at the residence of John Nicholas Brown. Apparently that was the risk of docking near a naval torpedo station.

The *Lone Star* became the *Moonstone* with help from the Gibbs Gas Engine Company of Jacksonville, Florida, which mounted a three-inch gun on the

forward deck, installed machine guns atop the superstructure and added two depth charge racks to the fantail. Each rack had eight depth charges. The sheltering canopies on the bow and on the top deck disappeared.

The yacht officially became a patrol boat on April 10, 1941, and on May 2, 1941, the crew affectionately called it the "Moon." The ship began patrolling around what was known as the Panama Sea Frontier. The ship was also used to train Ecuadorian soldiers. Ecuador wanted to buy the vessel, which in March 1943 visited Charleston, its home port, to prepare for the transfer in ownership. Upon its return to Balboa, located at the entrance to the Panama Canal, it was discovered that an engine had cracked cylinder blocks.

Off the ship went to Philadelphia for repairs. On October 15, 1943, the *Moonstone* entered a shroud of dense fog near the Delaware capes. It was wartime, so the ship was neither sporting navigation lights nor sounding a foghorn. (Both actions could have alerted enemy vessels to its presence.) At 11:18 p.m., the soundman noted a contact via his listening gear. Lieutenant Frank Walther, who stood on the port bridge wing, saw the shadow of an approaching ship. It was an ominous sight.

The 314-foot USS *Greer*, a four-stack destroyer, was launched by William Cramp & Sons Ship Company in Philadelphia on August 1, 1918. Named for Rear Admiral James A. Greer, the powerful battleship was the first to attack a German submarine in World War II, which it did on September 4, 1941. In October 1943, the *Greer* was headed to Hampton Roads, Virginia, from the Brooklyn Navy Yard, along with the USS *Vixen* and the USS *Upshur*. All three were blacked out.

Barreling along at thirteen knots, the *Greer*'s bow ground into the *Moonstone*'s port, shredding it open down to the keel. The impact was so strong that Yeoman Edmund Zine was tossed from off the mast and onto the deck.

In the velvety darkness, the *Moonstone*'s men rushed topside as the bridge flooded. Many preferred to take their chances and jump overboard. As Lieutenant Walter Curtis, the commanding officer, later said, "Before I could leave the ship, she sank under me."

The *Greer* shone its searchlights and launched a whaleboat. The moist fog made it a challenge to find survivors in the black water. Some struggled in the sea for nearly an hour. A cook, James Meade, did not survive despite attempts to resuscitate him. The *Greer* headed back to New York with the survivors, and the *Moonstone* was left where it sank.

In the 1970s, the wreck looked like a "picture perfect site that looked more like a Hollywood set than a real shipwreck," Gary Gentile wrote. But in 2007, the site looked more like a "gigantic, debris-filled metal bathtub than the graceful yacht."

The process of collapse, he concluded, is inevitable.

MYSTERY SHIPS

IN SEARCH OF CLUES

Divers chatting about wrecks off the Delaware coast have given the wrecks names that often border on the whimsical: Bob's Cold Spot, Independence Day, the Bimbo, Double L and Grocery Stop #2. These are wrecks that to this date have no name, and there are countless of them.

To determine a ship's origin requires infinite patience and plenty of clues, ranging from finding an artifact with a ship's name on it to uncovering a cannon with a registration mark that lines up with a ship manifest—which, in turn, also needs to be uncovered. As Gilbert McCracken's notation of *De Braak*'s resting point proves, a reported location of the wreck site is not a guarantee that the wreck is there—or that the wreck that is there is the right ship. Coasts are dynamic. Sands shift and water consumes the land. Debris will move, or it will be destroyed by fishing vessels and commercial activity, and wrecks fall atop one another.

There's no certainty of a ship's identity until several clues come together. Consider that the bell found at what was hoped to be *De Braak* site was actually French in origin and read *Le Patrocle 1781*. Some of the wood seemed as though it could have come from America. One clincher, however, was the discovery of a mourning ring that belonged to the captain, James Drew. The inscription read "In Memory of My belv'd Brother Capt. John Drew Drown'd 11 Jany. 1798 Aged 47."

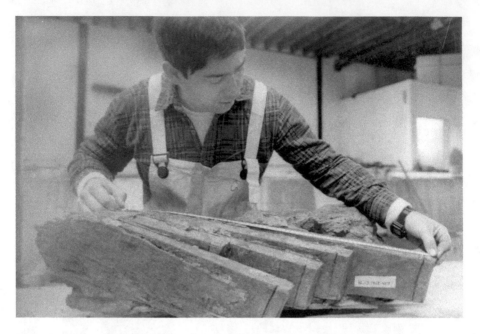

Wood found on a shipwreck can help identify a ship's origins. *De Braak*'s keel was made of elm, which signified its British or American origin, but it was believed to have originally been a Dutch ship. *Courtesy of the Delaware Public Archives.*

A prime example of how archaeologists use clues to attempt to determine a ship's identity is exemplified in the case of the Roosevelt Inlet shipwreck. In the fall of 2004, during a beach replenishment project on Lewes Beach, a dredge struck what turned out to be a wreck site. The quest to find the ship's name and origin would consume the professionals and volunteers who took on the mission. It is believed that the wreck is the *Severn*.

THE CASE OF THE ROOSEVELT INLET SHIPWRECK

It was a nasty nor'easter, not one that Captain James Hathorn would expect to encounter in early May. Hathorn was sailing the *Severn* from Bristol, England, to Philadelphia, its home port. It was 1774, and the ship carried materials the American colonists needed for daily life, such as earthenware jugs, mineral water, millstones and straight pins. Inhaling great gulps of frigid Canadian air, the storm hurled snow over the mid-Atlantic region. Philadelphia would later record six inches. The ship took on water. Seeking to save the lives of the crew, who numbered about twenty, Hathorn decided

to run aground. Although the crew survived, the ship was crippled. The *Pennsylvania Gazette* on May 11, 1774, reported that the *Severn* was "ashore in our bay full of water and is thought will be lost."

Years passed and the *Severn* was forgotten—until, that is, an Army Corps of Engineers dredging project, which pumped 11,000 cubic yards of sand from Roosevelt Inlet and another 165,000 cubic yards of sand from an offshore site, struck something underneath the water.

Beachcombers began finding broken pieces of pottery, metal, glass and other artifacts on Lewes Beach. Word spread and treasure hunters descended on the beach until state historians and archaeologists learned of the find from a reporter. What was the origin of the artifacts? Was it a long-gone settlement that had since been covered by encroaching waters? Or was it a shipwreck?

Initially, it was thought that the artifacts did indeed come from an old settlement, perhaps dating as far back as the 1600s. Some even hypothesized that it was the original Dutch whaling settlement of Swanendael, founded in 1631. But an examination of the artifacts determined that they were from the eighteenth and not the seventeenth century. Moreover, the distribution pattern on the beach debunked the idea that they came from a settlement. Instead, they were a product of the dredging, meaning that the source was located offshore.

A February 2005 sonar survey pinpointed a debris site about 2,400 feet from shore in twelve to fifteen feet of water. The dredge had intruded on about 20 percent of the site. Since the Army Corps of Engineers was deemed at fault for not properly surveying the site, it paid for a March 2005 dive, which produced artifacts matching those on the beach. The following month, divers recovered about two hundred artifacts and discovered what was later identified as a 71-foot-long lower deck clamp, a curved piece that runs inside the hull to support the deck. A top clamp would hold decking in place. Also that April, the newly formed Lewes Maritime Archaeology Project set up camp in a former World War II bunker in Cape Henlopen State Park, once the site of Fort Miles, where items were cleaned and de-ionized, so the salt would not crack an artifact when it dried out.

Identifying the artifacts' country of origin helped date the wreck. Three pipes had a mark from a manufacturer first registered in the Dutch pipe-making guild in 1769. Under-glaze painting on creamware did not start until 1770, which meant that the ship sunk after that time. There was no pearlware, a British ceramic that entered production in 1779. Such clues led

archaeologists to conclude that the ship had likely sunk between 1762 and 1775. By the spring of 2006, there were four candidates: the *Commerce*, lost in the area in 1771; the *Pitt Packet* and the *Vaughn*, both lost in 1763; or the *Severn*, lost in 1774. In the eighteenth century, it was common for insurance companies to insure both ships and ship cargos. The state hired a historical researcher in England to investigate public records, since paperwork still exists.

A second dive brought up about thirty thousand artifacts, which joined the nearly fifty thousand already discovered. Whether from the beach or the dive site, few large objects were found intact. When the ship ran aground, millstones probably careened into breakable objects, and boxes undoubtedly crashed against one another. After the storm, items in good condition were likely salvaged, and the remaining cargo was subjected to two centuries of dropped anchors, pilot boat activity and commercial and recreational fishing.

Smaller intact items, such as faceted pressed glass, cufflinks and thimbles, fared better over the years. Larger whole pieces included four stoneware

Glass bottles, such as these found at the *De Braak* wreck site, can help determine the age of a ship, especially if they are marked with a country of origin or a manufacturer's name. *Courtesy of the Delaware Public Archives.*

jugs, two complete mineral water bottles and a complete tin-glazed earthenware plate. But for researchers, a fragment is not such a bad thing. It allows them to better view the clay on a stoneware jug—even perform a chemical analysis.

In eighteenth-century Europe, quality control was very much in effect. Mineral water containers bear a number indicating the well from which the water came and a second number for the artisan who made the container. Judging by the corks, mineral bottles were full. The jugs were empty, signifying the colonists' and early Americans' dependence on England for rudimentary supplies, such as pipe stems, gun parts and sleeve-button settings.

When it came to identifying the Roosevelt Inlet wreck, perhaps the most significant items will fit in a fist. A button bears the date 1772; a Danish token is dated 1768. The dates rule out the *Pitt Packet* and the *Vaughn*, which sank in 1763, and the *Commerce*, which sank in 1771. A review of inbound commercial ships lost in the area left only one: the *Severn*.

Weighing two hundred tons, the *Severn* was owned by Thomas Penington, an importer and exporter. State archaeologists originally assumed that Penington was from Philadelphia, the *Severn*'s home port. The researcher in London discovered that he was from Bristol. Penington was involved in the slave trade. Ships made a circuit, picking up slaves in Africa, sugar and rum in the Caribbean, raw materials in North America and supplies in Europe. But the *Severn* was limited to the North American–Europe run. The ship at different times visited Spain, Portugal and Italy. A dated Italian coin is part of the artifact collection. There is also a Russian coin and an Austro-Hungarian coin, perhaps brought on board by sailors. The Dutch at that time traded heavily with Russians. The Dutch also traded with the English, and the South African wine could have come from Holland, which then occupied South Africa.

The *Severn*'s birth date is unknown. However, commercial wooden ships typically lasted just thirty years, either because an affluent merchant could afford to buy a new ship and keep current or because wooden ships required too much maintenance to keep pouring money into them. Of course, there was always a loss due to shipwrecks.

While the *Severn*'s 1774 voyage lacked a list of its crew and their hometowns, a 1767 list indicated that Hathorn was from Dublin. Subsequent lists linked Hathorn with Philadelphia. Eleven months after the *Severn*'s demise, Hathorn was captain of the *Olive Branch*, bound from Philadelphia to the Mediterranean. The American Revolution killed commerce until 1783, and

the *Severn* is believed to have been the last reported commercial ship lost along the Delaware coast until after the Revolution.

Is it enough? Does all that information prove that the ship is indeed the *Severn*? Not conclusively. Charles Fithian, curator of archaeology for Delaware's Division of Historical and Cultural Affairs, is comfortable with the dating of the wreck. "Can we absolutely say it is the *Severn*?" he asks. "I don't know. It looks right, but we've not found the absolute artifact or artifacts that say absolutely this is the *Severn*."

Regardless of whether the ship is the *Severn*, the shipwreck site has been added to the National Register of Historic Places. A name, it seems, is not always necessary to earn a ship recognition.

THE CHINA WRECK: KNOWN AND UNKNOWN

Nearly forty feet under the water, about twelve miles off Cape Henlopen, lies one of the area's best-known and yet least-known wrecks. For divers seeking souvenirs, the site is a treasure-trove, offering up more than ten thousand pieces of English chinaware, including "Alphabet" or ABC plates, which feature a literary or fairy tale hero, such as Goosey, Goosey Gander, ringed by the alphabet.

The sheer volume of earthenware has earned the wreck the name the "China Wreck." Its real name, however, is up for debate. The wreck was discovered in 1970 by the National Oceanic and Atmospheric Administration vessels *Rude* and *Heck*. The ships, each ninety feet long, were conducting hydrographic surveys. To scan for possible obstructions, the two ships were connected by a towing a wire, a survey method known as the "water-drag system." When the wire snags on an obstruction, the taught line forms a "V"—in this case a "V marks the spot" of a potential problem. Divers then examine the submerged object to determine if it's a navigational hazard.

In about thirty-five to forty feet of water, with ten feet of visibility, Lieutenant Merritt N. Walter, who directed the expedition, and divers found what was believed to be a late nineteenth-century British cargo vessel. The debris site was laden with chinaware, some of it unbroken and much of it neatly stacked. There were cups, saucers, bowls, pitchers and plates. Most of it was white, undecorated ironstone made for everyday use. Walter said that the site looked like "some kind of bargain basement sale a Macy's, with all the stuff stacked there waiting for the shoppers to arrive."

The divers brought up more than two hundred pieces of china, along with a silver pitcher and a 3,500-pound anchor from the site. "In the ten years of diving," Walter later mused, "all I ever brought up was rusty beer cans! Then all of a sudden I came across an old wreck that no one else has ever been on, its cargo still intact."

When the ship was declared no danger to navigation, the recreational divers descended on the site. Thanks to the tides and currents, visibility here is tricky. When the tide changes, it is as though a black wall approaches. Divers managed to bring up items, including a carpenter's grindstone and the first ABC plate. Tim Tattersall found the ship's bell within several minutes of his decent. There was, however, no ship's name engraved on the bell.

So what is identity of the mysterious China Wreck? Many maintain that the ship is the 483-ton *Principessa Margherita di Piemonte*, a bark from Naples, Italy, that was sailing from Plymouth, England, to Philadelphia with a cargo that included china clay and flint stone. On March 12, 1891, the ship foundered and wrecked on Hens and Chickens Shoal; Captain Cassaregola and his ten-man crew were rescued by members of the Lewes Life-Saving Station.

Critics point to the age of the China Wreck's cargo. Expert Jefferson Miller, curator of ceramic history at the Smithsonian Institution's National

ABC plates were part of the china found on a mysterious wreck dubbed the "China Wreck" for the amount of earthenware divers discovered. The true identity remains unknown. *Courtesy of DiscoverSea Museum.*

Museum of History and Technology, determined that some of the products were made by some manufacturers who ceased operation in the 1870s. If the ship is the *Principessa*, it was carrying china products that may have been in storage for up to two decades before shipment. Moreover, the *Principessa* was reported to have carried china clay, not fired china, and those who disagree note that that the China Wreck's remains are seven miles offshore from the *Principessa*'s reported position.

Dutch researcher Paul de Keijzer offered up the theory that the ship is the *D.H. Bills*, a brigantine that disappeared after leaving Liverpool, England, on January 19, 1880, en route to Wilmington, North Carolina. The vessel was born as a two-masted schooner-rigged screw steamer named *Huron*, one of twenty-three ninety-day gunboats built by the U.S. Navy after the Civil War's outbreak. The *Huron* was primarily part of the Union's blockade of the Confederacy, capturing several of the South's blockade runners. The *Huron* became the *D.H. Bills* after the ship was sold to a group of investors, one of whom was named Daul H. Bills, and it was likely re-rigged. The ship was apparently sold, as the 1880 Lloyd's Register of British and Foreign Shipping listed it as a brigantine owned by Daniel Jones of Chepstow, England.

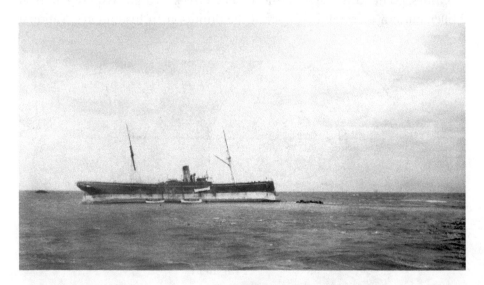

This unidentified ship is one of many that met disaster along the Delaware coast. Storms, human error and unexpected shallow areas brought down an untold number of vessels over the centuries. *Courtesy of the Lewes Historical Society.*

On its last voyage, the *D.H. Bills* carried 193 tons of salt in bulk, 37 tons of earthenware in crates and 25 tons of stone ballast. On May 20, 1880, the ship was listed as overdue. The next week, it officially made the missing list. Neither the ship nor Captain Sjobeck and his crew were heard from again. Perhaps the ship fell victim to a succession of violent storms. Several ships were lost during a March blizzard.

But again, the ship would have been carrying china made a significant amount of years before the voyage. Without cargo positively linked to the *D.H. Bill* or a recovered item with the ship's name on it, few will confirm that the China Wreck is the *D.H. Bill*.

The lack of a name, however, does not deter divers or tourism officials from promoting the wreck as part of the area's maritime lore or recreational dive sites. In brochures and books, the remains are quite simply known as the China Wreck. Its allure seems all the more magical because of its mystery.

That mystery is what keeps divers, treasure seekers and historians so interested in shipwrecks, which are like puzzles whose pieces are tossed about the seafloor. Put all the pieces together and you still might not see the entire picture: the men, the women, the children and the financiers who once breathed life, hope and love into the vessel.

At one time, many of these ships carried dreams along with their cargo, but for many the dreams died on one fateful night, day or morning when the ship collided with destiny.

BIBLIOGRAPHY

Bullard, Michael S. *Diving the China Wreck*. Haverford, PA: Infinity Publishing, 2003.

Burris, Dave. "The Origins of Delaware Pilotage." *Coastal Sussex Weekly* 34, no. 3 (December 2009).

Charles, Joan D. *New Jersey, Delaware, Pennsylvania Shipwreck Accounts 1705–1950*. Hampton, VA: self-published, 2003.

Diehl, James. *Remembering Sussex County*. Charleston, SC: The History Press, 2009.

The Federal Reporter Volume 43 Cases Argued and Determined in the Circuit and District Courts of the United States September–December 1890. St. Paul, MN: West Publishing Co., 1891.

Federal Writers' Project of the Works Progress Administration for the State of Delaware. *Delaware: A Guide to the First State*. New York: Viking Press, 1938.

Flint, Willard. *A History of U.S. Lightships*. Online edition. Coast Guard Historian's Office, May 1993. http://www.uscg.mil/History/articles/Lightships.pdf.

Gentile, Gary. *Shipwrecks of Delaware and Maryland*. Philadelphia, PA: Gary Gentile Productions, 2002.

George, Pam. "Coastal Ghosts." *Delaware Beach Life* magazine (October 2006).

———. "Mystery off Lewes." *Delaware Beach Life* magazine (Winter/Spring 2006).

———. "Secrets of the DeBraak." *Delaware Beach Life* magazine (October, 2004).

———. "Undersea Mystery." *Delaware Beach Life* magazine (March/April 2007).

Harrison, Tim, and Ray Jones. *Lost Lighthouses: Stories and Images of America's Vanished Lighthouses*. Guilford, CT: Globe Pequot, 2000.

Hurley, George M., and Suzanne B. Hurley. *Shipwrecks and Rescues along the Barrier Islands of Delaware, Maryland, and Virginia*. Norfolk, VA: Donning, 1984.

Jennings, Lee, and Gary Wray. *Images of America: Fort Miles*. Chicago: Arcadia Publishing Company, 2005.

Kinnane, Adrian. *DuPont: From the Banks of the Brandywine to the Miracles of Science*. Wilmington, DE: E.I. du Pont de Nemours and Company, 2002.

Kirkin, Wayne. *Lightships: Floating Houses of the Mid-Atlantic*. Charleston, SC: The History Press, 2007.

Klein, Don. "Restored Station Is Part of Coastal Delaware's Maritime Heritage." *Delaware Beach Life* magazine (Winter 2005).

Kotowski, Bob. *Ablaze in Lewes Harbor*. Wilmington, DE: Cedar Tree Books, 2007.

Martelli, Patricia A. *Haunted Delaware: Ghosts and Strange Phenomena of the First State*. Mechanicsburg, PA: Stackpole Books, 2006.

Marvil, James E. *A Pictorial History of Lewes, Delaware 1609–1985*. Lewes, DE: Lewes Historical Society, 1985.

Meehan, James D. *My, But the Wind Did Blow*. Bethany Beach, DE: Harold E. Dukes Jr., 2003.

Mervine, William M. "Pirates and Privateers in the Delaware Bay and River." *Pennsylvania Magazine of History and Biography*. Vol. 32. Philadelphia, PA: Historical Society of Philadelphia, 1908.

Morgan, Michael. *Pirates & Patriots: The Tales of the Delaware Coast*. New York: Algora Publishing, 2005.

Okonowicz, Ed. *Terrifying Tales 2 of the Beaches and Bays*. Elkton, MD: Myst and Lace Publishers, 2001.

Parks, Lynn. "Guiding Lights." *Delaware Beach Life* magazine (May 2005).

Plowman, Terry. "Salvation Navy." *Delaware Beach Life* magazine (Winter 2005).

Scharf, J. Thomas. *History of Delaware: 1609–1888*. Philadelphia, PA: L.J. Richards & Co, 1888.

Schwartz, Rick. *Hurricanes and the Middle Atlantic States*. Alexandria, VA: Blue Diamond Books, 2007.

Seibolt, David J., and Charles J. Adams. *Shipwrecks, Sea Stories, and Legends of the Delaware Coast*. Barnegat Light, NJ: Exeter House, 1989.

Shomette, Donald G. *The Hunt for HMS De Braak: Legend and Legacy*. Durham, NC: Carolina Academic Press, 1993.

———. *Shipwrecks, Sea Raiders, and Maritime Disasters along the Delmarva Coast 1632–2004*. Baltimore, MD: Johns Hopkins University Press, 2007.

Snyder, Frank, Captain. *A Gould Island Chronology and Some Associated Historical Notes.* A paper appearing on the website of the Jamestown [Rhode Island] Historical Society. http://www.jamestownhistoricalsociety.org/assets/files/Gould%20Island.pdf.

Stevens, Bob. "A History of the U.S. Life-Saving Service." Online article on the Ocean City Museum Life-Saving Museum website. http://www.ocmuseum.org/index.php/site/usls-serv_article/a_history_of_the_us_life_saving_service.

Trapani, Bob, Jr. *Delaware Lights: A History of Lighthouses in the First State.* Charleston, SC: The History Press, 2007.

———. *Journey Along the Sands.* Virginia Beach, VA: Donning Company, 2002.

———. *Lighthouses of New Jersey and Delaware.* Elkton, MD: Myst and Lace Publishers, 2005.

United States Coast Pilot: Atlantic Coast, Section C: Sandy Hook to Cape Henry including the Delaware and Chesapeake Bays. Washington, D.C.: Government Printing Office, 1916.

Yeats, Jasper Hon. *Reports of Cases Adjudged in the Supreme Court of Pennsylvania: With Some Select Cases at Nisi Prius and in the Circuit Courts.* Philadelphia, PA: John Campbell, 1871.

NEWSPAPERS

Baltimore Sun
New York Times
Philadelphia Inquirer
Wilmington (DE) Evening Journal
Wilmington (DE) Morning News
Wilmington (DE) News Journal

ABOUT THE AUTHOR

Pam George regularly writes about maritime history for *Delaware Beach Life*, *Delaware Today* and *Coastal Sussex Weekly*. She also writes on food, health, technology, travel and business for such publications as *Fortune*, *Christian Science Monitor*, *Antiques Roadshow Insider*, *US Airways* magazine and *My Midwest*. Raised in Devon, Pennsylvania, she now lives in Wilmington, Delaware, with her husband, Steve. As a result, she knows the difference between going to the beach (Delaware) and going "down the shore" (Jersey). This is her first book.

Visit us at
www.historypress.net